FEAR,
Illustrated)

Transforming What Scares Us

Julie M. Elman

PARALLAX PRESS

BERKELEY, CALIFORNIA

PARALLAX PRESS

Parallax Press
P.O. Box 7355
Berkeley, CA 94707
parallax.org

Parallax Press is the publishing division of Unified Buddhist Church, Inc.
© 2016 Julie M. Elman
All rights reserved
Printed in China

Cover and text design by John Barnett | 4eyesdesign.com
Author photograph © Kelly Bondra

Library of Congress Cataloging-in-Publication Data is available on request.

1 2 3 4 5 / 20 19 18 17 16

ISBN: 978-1-941529-55-3

FSC
www.fsc.org
MIX
Paper from
responsible sources
FSC® C008047

For Jody,
who accepts me as I am,
fears and all.

Contents

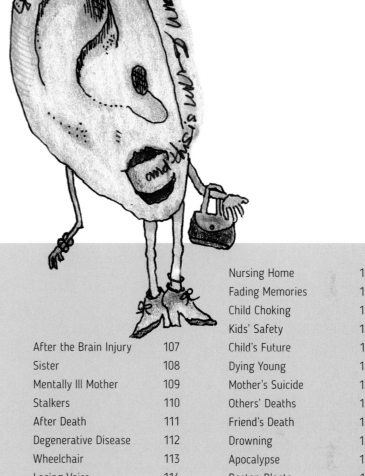

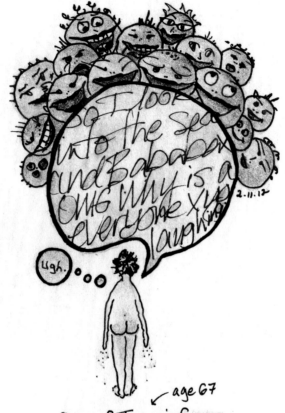

age 67

One of Terry's fears:
"Speaking or reading
in public."
Coping strategy:
"I perform. I practice
performance. I memorize
rather than read."

Introduction

I have more fears than I'd like to admit. One minute I'm wondering about rogue cancer cells that might be multiplying inside of me, the next moment I'm pondering my future, wondering if I'll end up a lonely, demented, destitute old lady.

The fears go on and on.

I'm now in my fifties, and despite decades of making what I'd consider to be some fearless life choices, the energy I've spent on fear has nevertheless surprised me. So in an effort to better understand this darker place, I decided to look at it in a different way: I asked other people what they were most afraid of. Without hesitation, friends, family, colleagues, students, and strangers willingly shared their fears with me.

That's when I started drawing.

From the beginning, the themes ran the gamut and included failure, losing a child, centipedes in the shower, small holes, rats, working too hard, escalators, biscuits, getting fat, dying alone, needles, and the impulse to jump from high places. Relying on my intuition (I mean, what does fear look like, anyway?), I went to work to create images that visually brought these fears out into the open and onto the page.

Why talk about fear? Because needless to say, we live in a world where fear is a driving force. Fear sells ("Buy this, or else!"), persuades ("Repent, or ye shall be damned!"), and makes us snap to attention ("Migrants!" "Ebola!" "Terrorists!"). Daily headlines remind us constantly that the world is a scary place, and if we're not scared, then we're not prepared—or so we are led to believe.

When I first began this project, I tried to organize these fears into categories: existential fears, physical fears, psychological ones. But, in fact, fears are porous—they overlap with each other, don't respect clear boundaries, and insinuate themselves into our lives in nonlinear ways. They also tend to propagate among us. "There is no passion as contagious as that of fear," French philosopher Michel de Montaigne once mused.

People have often asked me if it brings me down to confront and contemplate this litany of fears. In fact, it's quite the opposite. I'm inspired by people's honesty and vulnerability as they talk about whatever scares them, and fascinated by how they respond to my visual interpretation of their fears. "Seeing my fear makes it less scary and gives me a sense of peace," one woman told me. "The fear felt like a bowling ball that I kept holding, but now I've thrown it. It's still out there. It might always be out there, but I don't feel like I'm weighed down."

I've heard this sentiment expressed in various ways by many others. I find it affirming that this project has resonated so strongly with people, simply because of how deeply embedded fear is in our everyday lives.

You and I, we are not alone.

Julie M. Elman

The Fears

Sometimes I worry that my teeth are just going to randomly fall out of my mouth.
Sometimes I have nightmares that they slowly drop out of my head one by one...

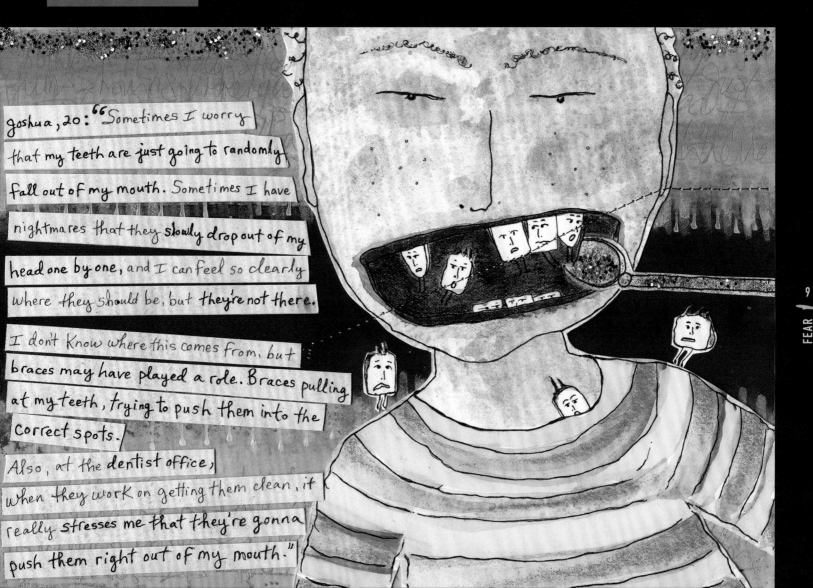

Joshua, 20: "Sometimes I worry that my teeth are just going to randomly fall out of my mouth. Sometimes I have nightmares that they slowly drop out of my head one by one, and I can feel so clearly where they should be, but they're not there.

I don't know where this comes from, but braces may have played a role. Braces pulling at my teeth, trying to push them into the correct spots.

Also, at the dentist office, when they work on getting them clean, it really stresses me that they're gonna push them right out of my mouth."

Skye, 22: "I have a fear of **biscuits.**
It started when I was in first grade,
because my parents sent me to Girl Scout camp,
and I wasn't a Girl Scout, but they just
wanted to get rid of me for a week in the summer.

At camp, they are all about **not wasting food.**
You have to clean your plate every night.
And I've never liked bread that much,
but **I really just hated biscuits.**

And they force-fed them to me at this camp.
And I, like, **threw up biscuits.**
It was horrible. And since then, it's
gotten worse.

It's like such an irrational fear, and my
friends at college have been **awful about it.**
Like, I've gone to my friend's apartment
before, and my friends have just **thrown
biscuits at me** till I ran out of the room.

Last week was my birthday, and my
friend actually put a **bunch of biscuits**
in an amazon box, like I was getting a
real present. I opened it, and **I
screamed so loud** and **threw them**
at her. It's really embarrassing."

BISCUITS
Skye, 22

I have a fear of biscuits.... And they force-fed them to me at this camp.
And I, like, threw up biscuits. And since then, it's gotten worse.

BANANAS

Emily, 21

I'm scared of bananas. They just freak me out.... Maybe my mom force-fed me bananas when I was a kid.

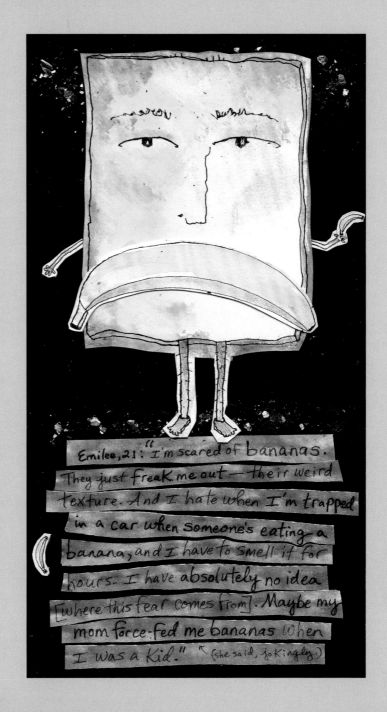

Emilee, 21: "I'm scared of bananas. They just freak me out — their weird texture. And I hate when I'm trapped in a car when someone's eating a banana, and I have to smell it for hours. I have absolutely no idea [where this fear comes from]. Maybe my mom force-fed me bananas when I was a kid." (she said, jokingly)

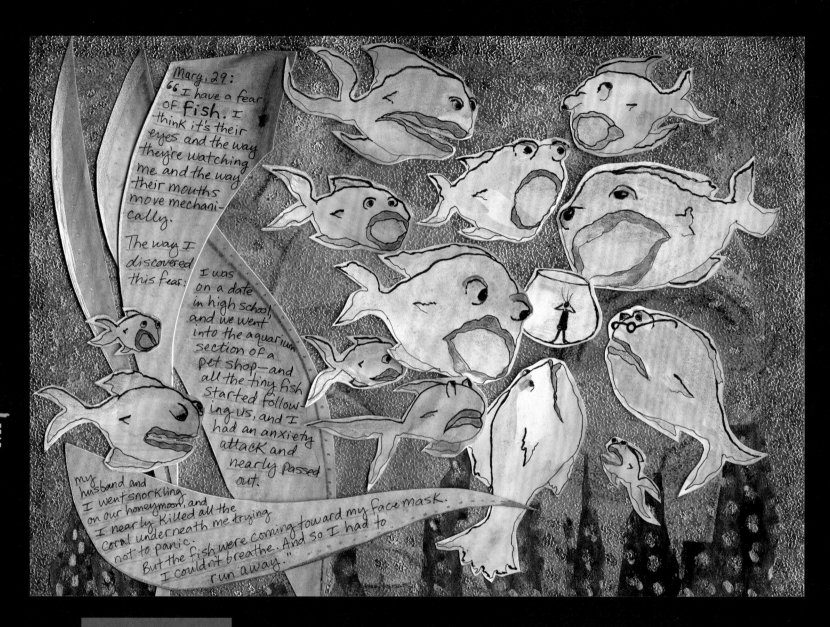

Mary, 29:
"I have a fear of **fish**. I think it's their eyes and the way they're watching me and the way their mouths move mechanically.

The way I discovered this fear: I was on a date in high school, and we went into the aquarium section of a pet shop—and all the tiny fish started following us, and I had an anxiety attack and nearly passed out.

my husband and I went snorkling on our honeymoon, and I nearly killed all the coral underneath me trying not to panic. But the fish were coming toward my face mask. I couldn't breathe. And so I had to run away."

FISH
Mary, 29

I have a fear of fish. I think it's their eyes and the way they're watching me and the way their mouths move mechanically.

SEAWEED
Andie, 13

I'm scared of seaweed.... I just don't like it. I get scared whenever it touches me. I honestly don't know what would happen if it did.

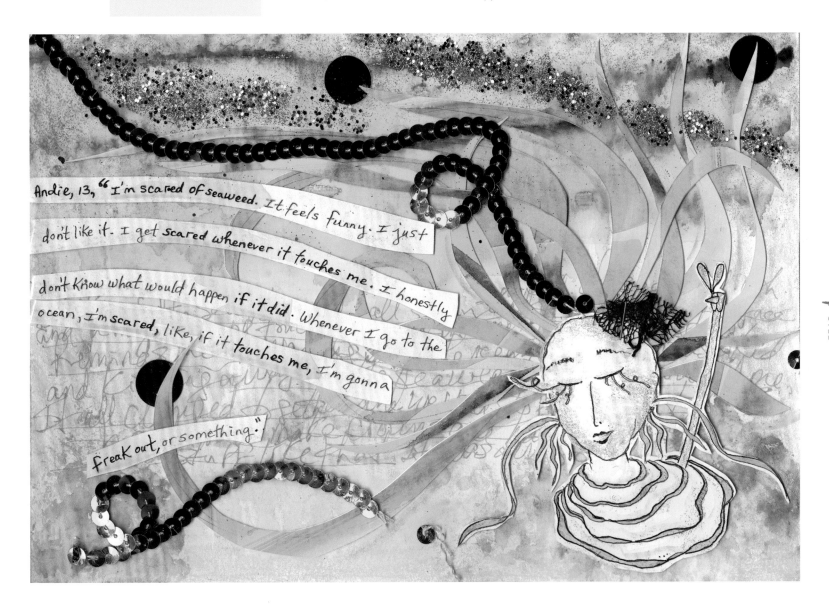

Andie, 13, "I'm scared of seaweed. It feels funny. I just don't like it. I get scared whenever it touches me. I honestly don't know what would happen if it did. Whenever I go to the ocean, I'm scared, like, if it touches me, I'm gonna freak out, or something."

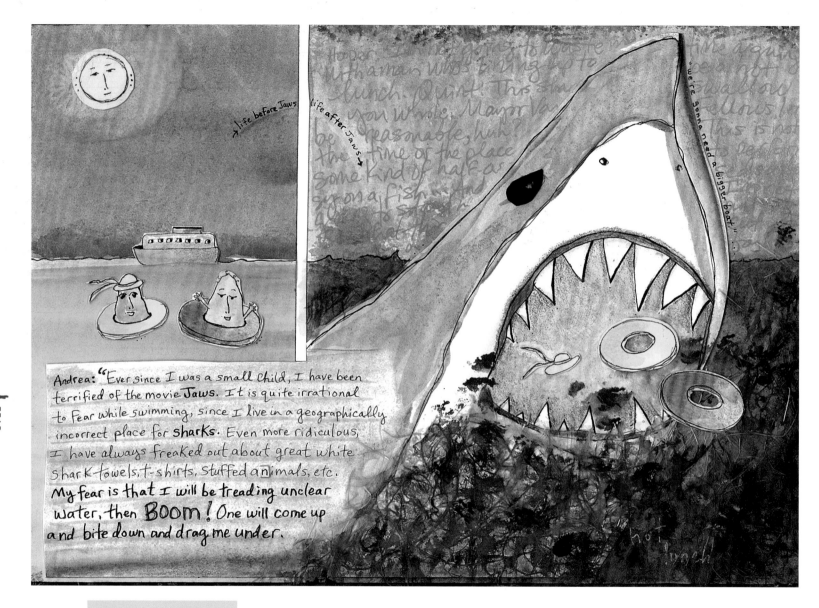

SHARKS
Andrea

Ever since I was a small child I have been terrified of the movie *Jaws*. It is quite irrational to fear while swimming, since I live in a geographically incorrect place for sharks.

I grew up in the desert.... When it does rain, it pours briefly, then the ditches that travel through the city are suddenly flooded.... For years as a child I didn't understand what an undertow was and just thought that when the rain came it carried with it this toad that would suck people under.

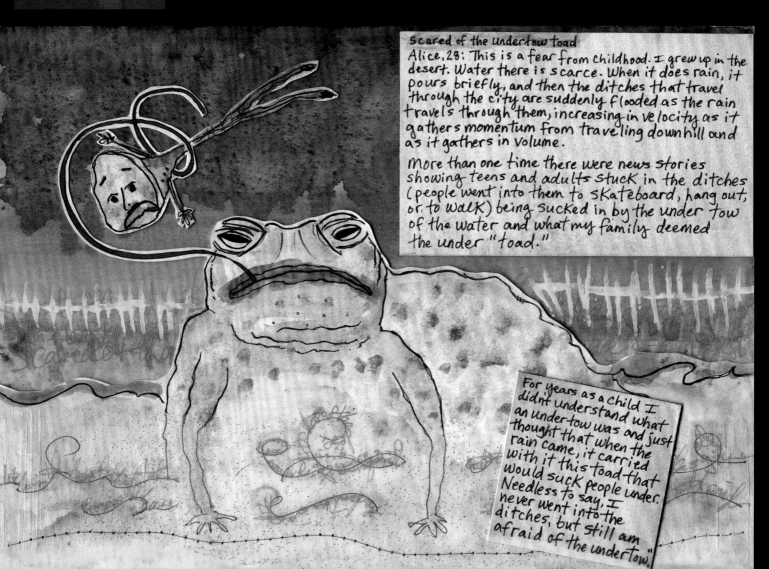

Scared of the undertow toad

Alice, 28: This is a fear from childhood. I grew up in the desert. Water there is scarce. When it does rain, it pours briefly, and then the ditches that travel through the city are suddenly flooded as the rain travels through them, increasing in velocity as it gathers momentum from traveling downhill and as it gathers in volume.

More than one time there were news stories showing teens and adults stuck in the ditches (people went into them to skateboard, hang out, or to walk) being sucked in by the under tow of the water and what my family deemed the under "toad."

For years as a child I didn't understand what an undertow was and just thought that when the rain came, it carried with it this toad that would suck people under. Needless to say, I never went into the ditches, but still am afraid of the undertow."

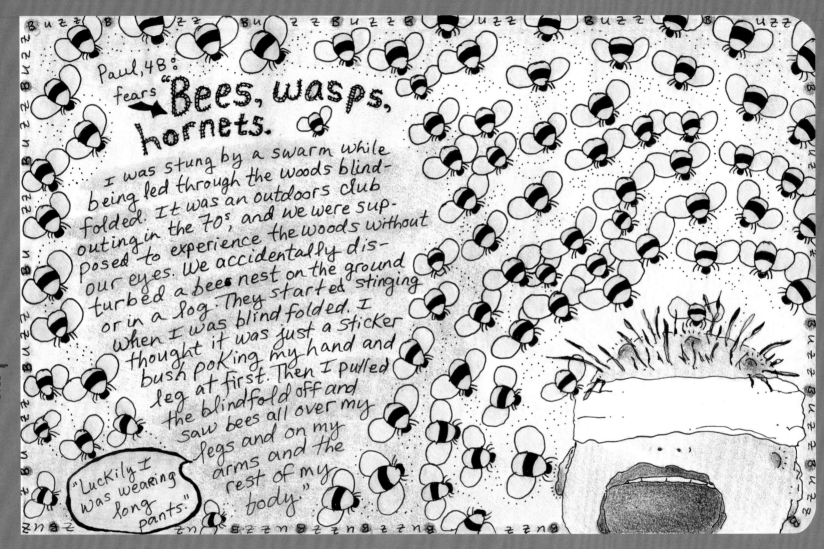

BEES

Paul, 48

I was stung by a swarm while being led through the woods blindfolded.

CAR WASH
Jessica, 28

I have a fear of driving into the car wash. I just don't like driving into such a small area, and then basically losing control of my car.

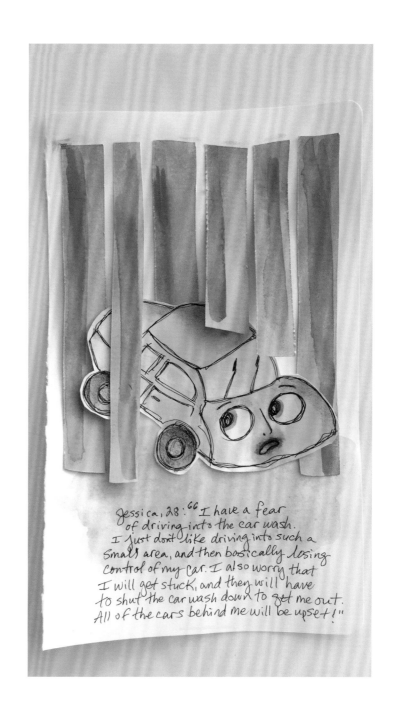

NEEDLES
Carrie

I am totally scared of needles. Just the thought of something piercing my skin sends me into a panic.

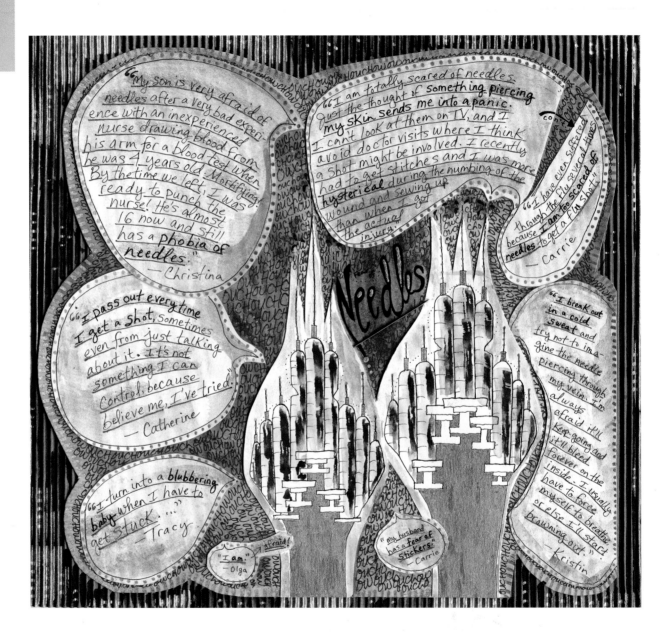

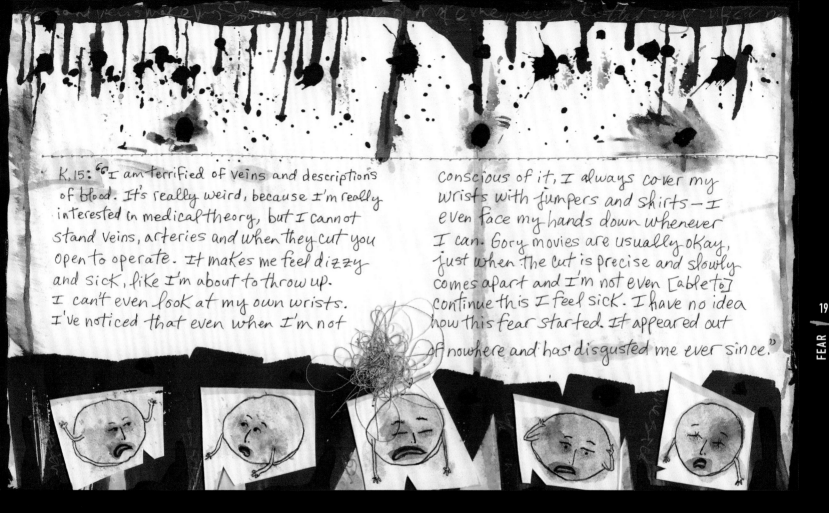

K. 15: "I am terrified of veins and descriptions of blood. It's really weird, because I'm really interested in medical theory, but I cannot stand veins, arteries and when they cut you open to operate. It makes me feel dizzy and sick, like I'm about to throw up. I can't even look at my own wrists. I've noticed that even when I'm not conscious of it, I always cover my wrists with jumpers and shirts — I even face my hands down whenever I can. Gory movies are usually okay, just when the cut is precise and slowly comes apart and I'm not even [able to] continue this I feel sick. I have no idea how this fear started. It appeared out of nowhere and has disgusted me ever since."

VEINS AND BLOOD
K, 15

I am terrified of veins and descriptions of blood. It's really weird, because I'm really interested in medical theory, but I cannot stand veins, arteries, and when they cut you open to operate.

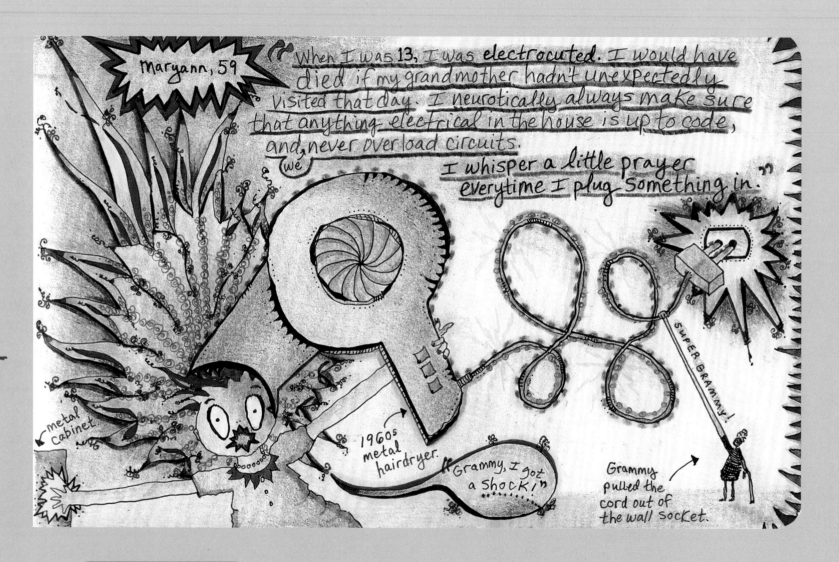

ELECTROCUTION

Maryann, 59

When I was 13, I was electrocuted.... I whisper a little prayer every time I plug something in.

CURLY HAIR
Lincoln, 21

I'm really scared to get it all chopped off—that my hair will decide it doesn't want to curl anymore, or it's going to go into tiny little curls, and I'm going to look like I'm 8 years old, or that something crazy's going to happen.

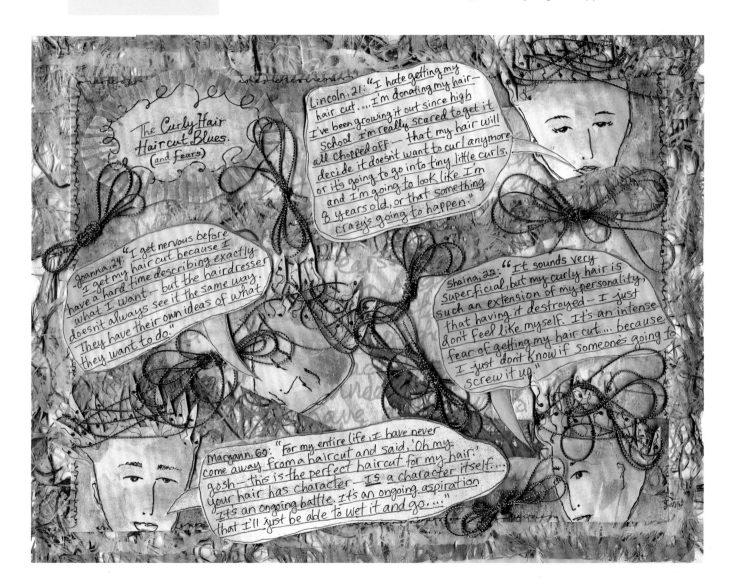

COP STOP
David, 51

Being stopped by a cop while driving. We both have the same visceral reaction.... It's a displaced fear of our father, who was forever watching for infractions and meting out brutal summary justice.

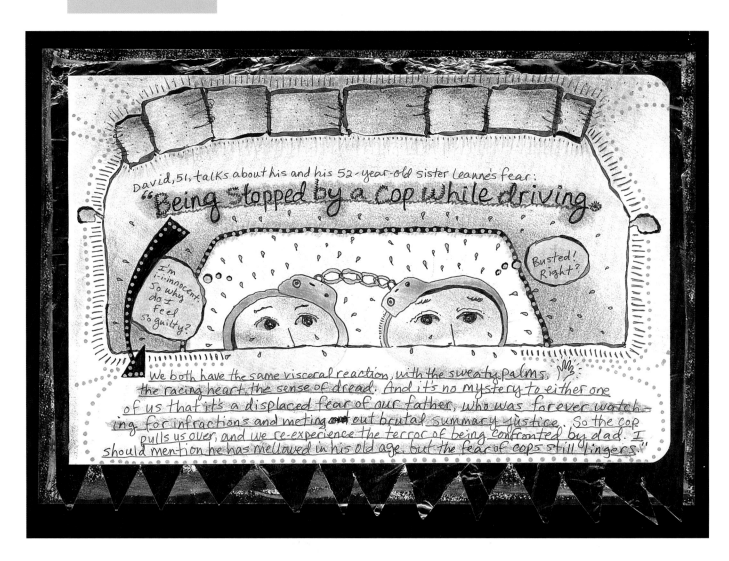

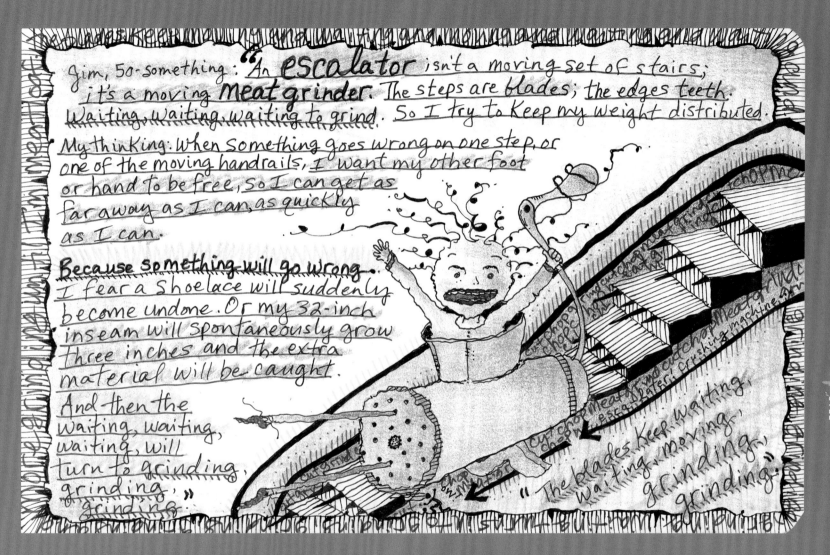

Jim, 50-something: "An **escalator** isn't a moving set of stairs; it's a moving **meat grinder**. The steps are blades; the edges teeth. Waiting, waiting, waiting to grind. So I try to keep my weight distributed.

My thinking: When something goes wrong on one step, or one of the moving handrails, I want my other foot or hand to be free, so I can get as far away as I can, as quickly as I can.

Because something will go wrong. I fear a shoelace will suddenly become undone. Or my 32-inch inseam will spontaneously grow three inches and the extra material will be caught. And then the waiting, waiting, waiting, will turn to grinding, grinding, grinding."

"The blades keep waiting, waiting, moving, grinding, grinding."

ESCALATORS
Jim, 50-something

An escalator isn't a moving set of stairs; it's a moving meat grinder.
The steps are blades; the edges teeth.

DOG
in three parts

DOG, PART 1
Kim, 53

When I was 7 years old, I was viciously attacked by our neighbor's German Shepherd named Duke.... Duke escaped out a back door that had been left open and ran at full speed for me, then knocked me to the ground, straddled on top of me and proceeded to rip my dress, dragging me around like a rag doll.

Kim, 53: When I was 7 years old, I was viciously attacked by our neighbor's German Shepherd named Duke. I had walked down the street to show my friend my new dress from my grandmother. She had sewn it to fit her VERY SKINNY granddaughter who could never buy ready-made clothes.

I stood outside the chain link fence surrounding the neighbor's yard until my friend and her brother put Duke up in the house. But just as I got half-way into their yard, Duke escaped out a back door that had been left open and ran at full speed for me, then knocked me to the ground, straddled on top of me and proceeded to rip my dress, dragging me around like a rag doll. I remember lying on my back, with my arms outstretched, digging my fingers into the ground... I was screaming... It seemed like forever, but eventually the parents came out of the house and had to beat Duke off of me with their golf clubs. He was later put down.

AHHHHHH!

I can't say I saw my guardian angel that day, but his presence was there, I'm sure, because I didn't have any scars (physical) from that day — only a shredded dress.

But what happened two years ago left me shaken to the core...

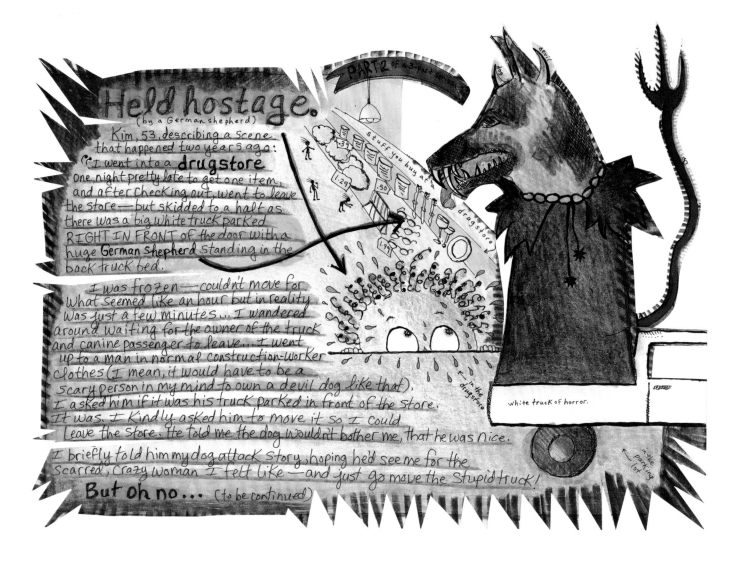

Held hostage.
(by a German shepherd)

PART 2 of a 3-part series

Kim, 53, describing a scene that happened two years ago:

"I went into a **drugstore** one night pretty late to get one item, and after checking out, went to leave the store—but skidded to a halt as there was a big white truck parked RIGHT IN FRONT of the door with a huge German shepherd standing in the back truck bed.

I was frozen—couldn't move for what seemed like an hour but in reality was just a few minutes... I wandered around waiting for the owner of the truck and canine passenger to leave... I went up to a man in normal construction-worker clothes (I mean, it would have to be a scary person in my mind to own a devil dog like that). I asked him if it was his truck parked in front of the store. It was. I kindly asked him to move it so I could leave the store. He told me the dog wouldn't bother me, that he was nice.

I briefly told him my dog attack story, hoping he'd see me for the scarred, crazy woman I felt like—and just go move the stupid truck!

But oh no... (to be continued)

stuff you buy at a drugstore

.39
1.29
.50
1.99

in the drugstore

white truck of horror.

in the parking lot

DOG, PART 2
Kim, 53

I went into a drugstore one night pretty late...but skidded to a halt as there was a big white truck parked RIGHT IN FRONT of the door with a huge German Shepherd standing in the back truck bed.

DOG, PART 3
Kim, 53

He grabs me by the hand and PULLS me out the door and straight to his truck. tells me to go ahead and pet his dog, thinking this will get me over my fear.

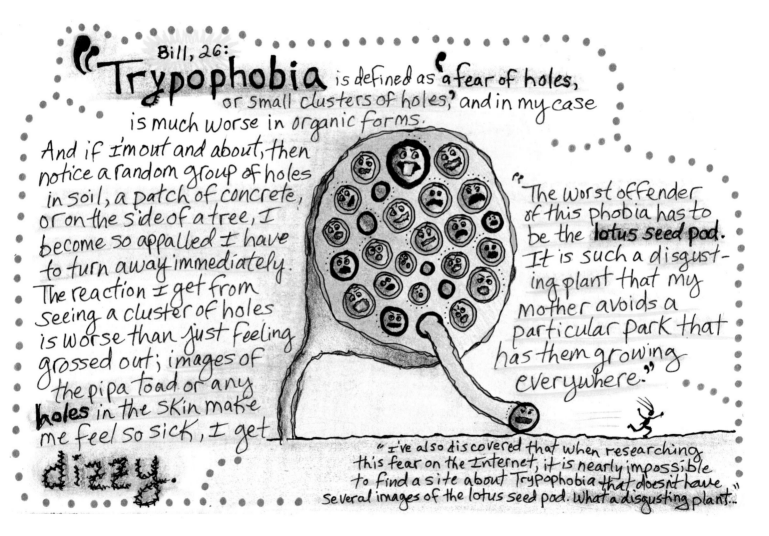

SMALL HOLES
Bill, 26

Trypophobia is defined as "a fear of small holes, or small clusters of holes," and in my case is much worse in organic forms. And if I'm out and about, then notice a random group of holes in soil, a patch of concrete, or on the side of a tree, I become so appalled I have to turn away immediately.

Bill, 26:
"**Trypophobia** is defined as 'a fear of holes, or small clusters of holes,' and in my case is much worse in organic forms.

And if I'm out and about, then notice a random group of holes in soil, a patch of concrete, or on the side of a tree, I become so appalled I have to turn away immediately. The reaction I get from seeing a cluster of holes is worse than just feeling grossed out; images of the pipa toad or any **holes** in the skin make me feel so sick, I get **dizzy.**

"The worst offender of this phobia has to be the **lotus seed pod.** It is such a disgusting plant that my mother avoids a particular park that has them growing everywhere."

"I've also discovered that when researching this fear on the Internet, it is nearly impossible to find a site about Trypophobia that doesn't have several images of the lotus seed pod. What a disgusting plant..."

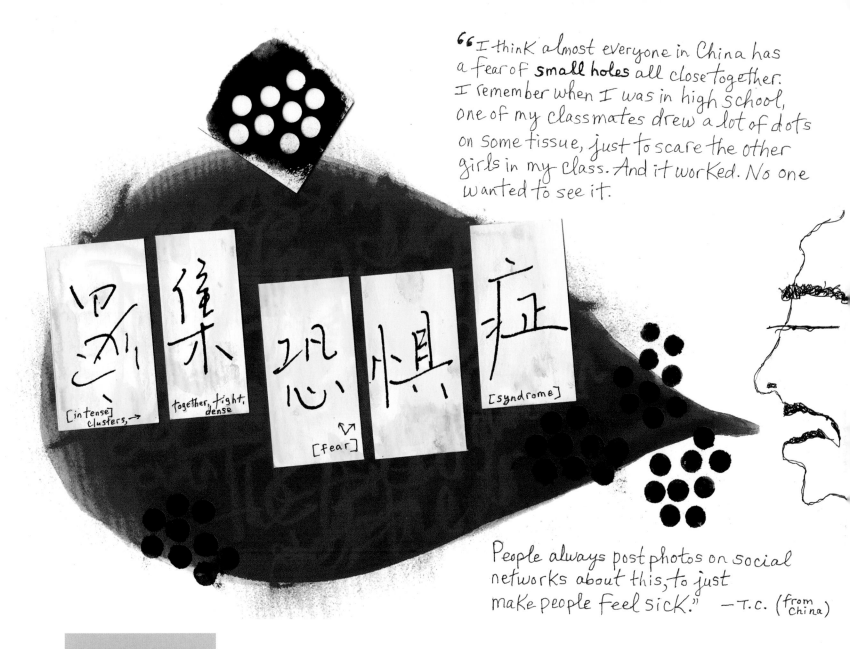

"I think almost everyone in China has a fear of **small holes** all close together. I remember when I was in high school, one of my classmates drew a lot of dots on some tissue, just to scare the other girls in my class. And it worked. No one wanted to see it.

People always post photos on social networks about this, to just make people feel sick." —T.C. (from China)

[intense] clusters, →

together, tight, dense

[fear]

[syndrome]

SMALL HOLES IN CHINA

TC, from China

I think almost everyone in China has a fear of small holes all close together.

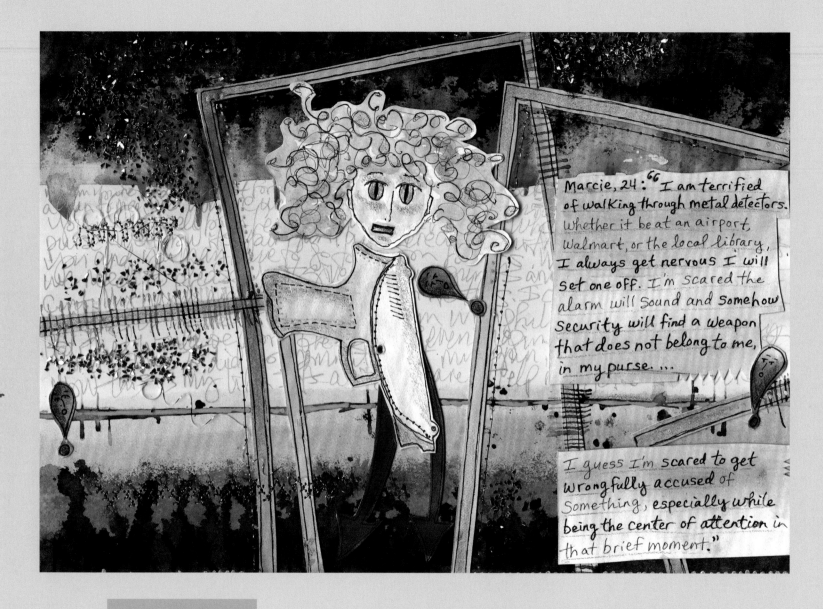

METAL DETECTORS
Marcie, 24

I am terrified of walking through metal detectors.... I'm scared to get wrongly accused of something, especially while being the center of attention in that brief moment.

FLYING
Eason

Every single time I hear the word turbulence, I just feel like "OK–this is death."

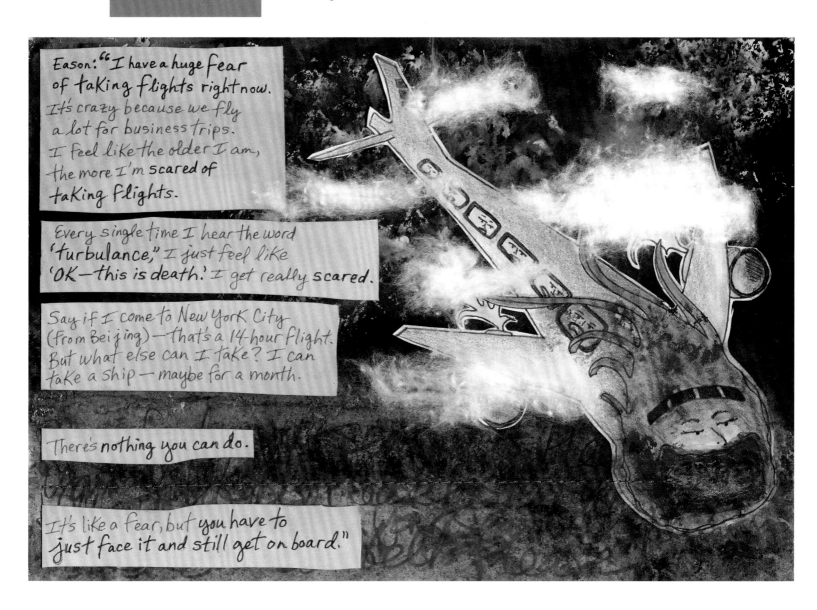

Eason: "I have a huge fear of taking flights right now. It's crazy because we fly a lot for business trips. I feel like the older I am, the more I'm scared of taking flights.

Every single time I hear the word 'turbulance,' I just feel like 'OK—this is death.' I get really scared.

Say if I come to New York City (from Beijing)—that's a 14-hour flight. But what else can I take? I can take a ship—maybe for a month.

There's nothing you can do.

It's like a fear, but you have to just face it and still get on board."

OVERFLOWING
TOILET
H, 60

I developed a fear
of being in a locked
bathroom with the
water filling up the
room until there was
no more air to breathe
up near the ceiling.

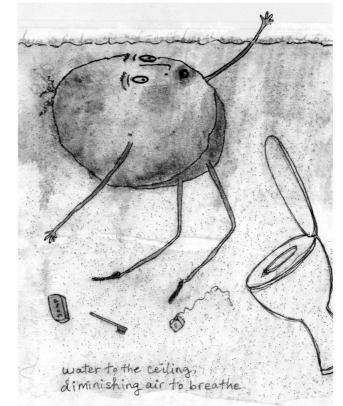

water to the ceiling,
diminishing air to breathe.

H. 60: "When I was a kid, we
had a toilet that overflowed often,
and I developed a fear of being
in a locked bathroom with the
water filling up the room until
there was no more air to breathe
up near the ceiling. Even today,
I won't watch movies or scenes
where there is a drowning
inside of ships (Titanic!) or other
enclosed spaces under water."

Emily, 20: "When I was about 10, I went on a trip to Arizona, and I got stuck in the airplane bathroom — and I had to call for the flight attendant to come get me out. And she couldn't even open the door, and I thought I was going to have to go out the fire escape. Ever since then I haven't been able to use an airplane bathroom." *

Q: Did you panic?

A: Oh, I was crying.

OCCUPIED

{The lock got stuck.}

* Emily shared this fear with me shortly before boarding a plane (for a seven-hour flight).

AIRPLANE RESTROOM
Emily, 20

When I was about 10, I went on a trip to Arizona, and I got stuck in the airplane bathroom.... Ever since then I haven't been able to use an airplane bathroom.

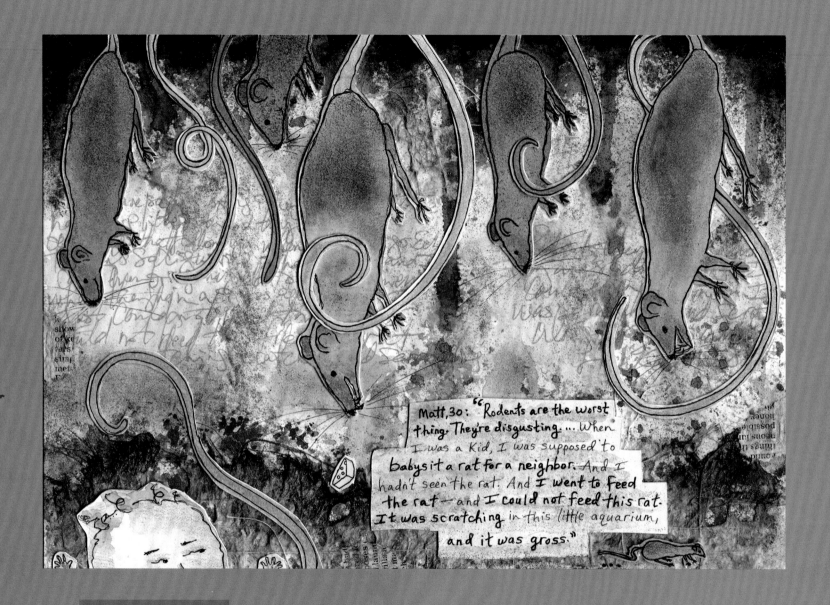

RATS

Matt, 30 Rodents are the worst thing. They're disgusting.

ROACHES

Jo, 77

I have always been afraid of them.... Now, being alone, I keep a spray gun handy, so when I spot one, I shoot it, and hope it dies in sight, or I always wonder.

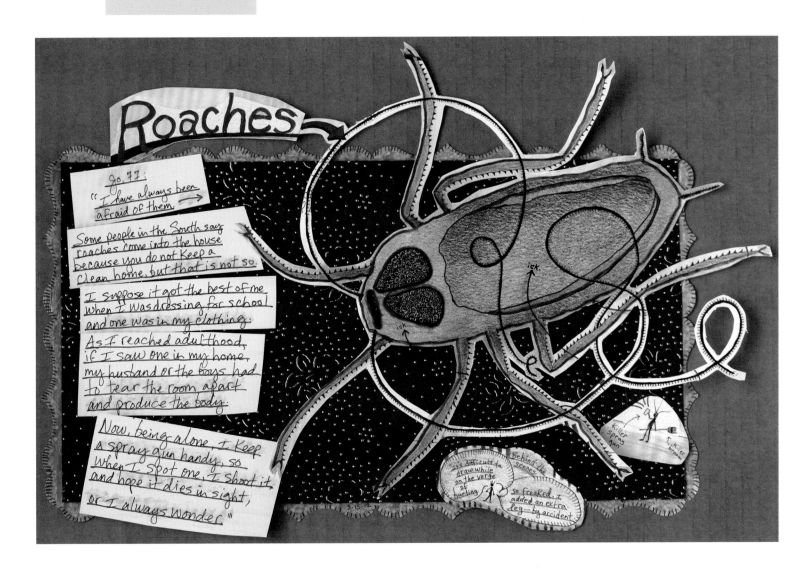

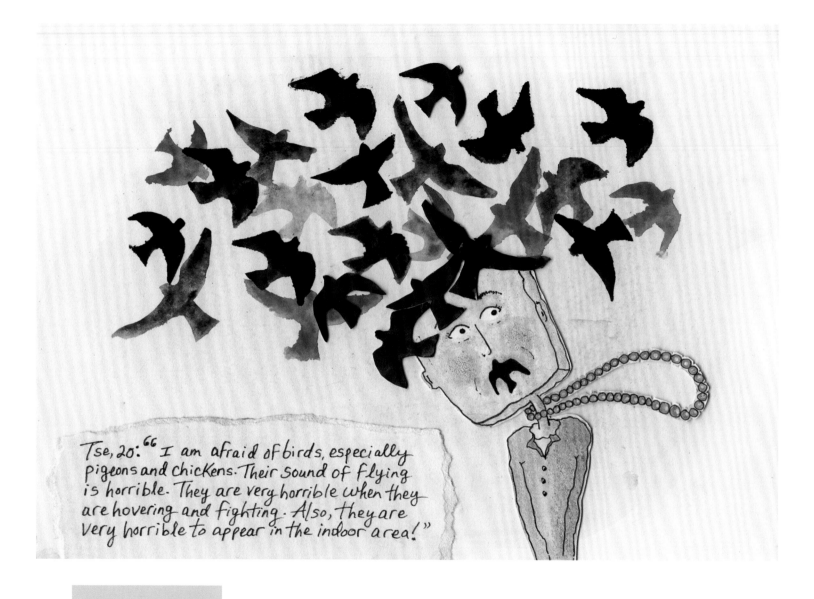

Tse, 20: " I am afraid of birds, especially
pigeons and chickens. Their sound of flying
is horrible. They are very horrible when they
are hovering and fighting. Also, they are
very horrible to appear in the indoor area!"

BIRDS
Tse, 20

I am afraid of birds, especially pigeons and chickens.
Their sound of flying is horrible.

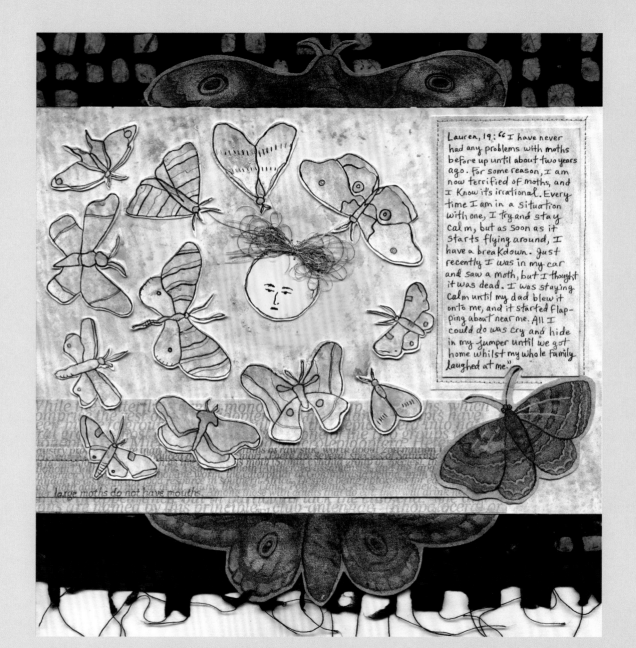

For some reason,
I am now terrified
of moths.

Lauren, 19: "I have never had any problems with moths before up until about two years ago. For some reason, I am now terrified of moths, and I know it's irrational. Every time I am in a situation with one, I try and stay calm, but as soon as it starts flying around, I have a breakdown. Just recently I was in my car and saw a moth, but I thought it was dead. I was staying calm until my dad blew it onto me, and it started flapping about near me. All I could do was cry and hide in my jumper until we got home whilst my whole family laughed at me."

large moths do not have mouths

We live in this really old house, and sometimes I see centipedes crawling around in the shower.

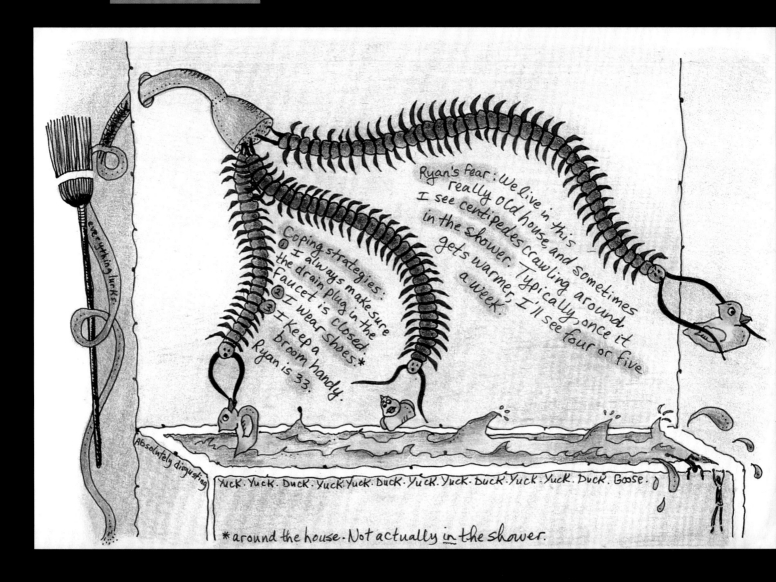

Alex,24: "I think I'm the only nature photographer who is terrified of SNAKES.

I can't remember a time when I haven't run the other way! I also don't like movies or pictures of snakes (which made me dislike the bad guys in Harry Potter all the more).

Currently, there is a rat snake living in our backyard... The last time I saw it, I ran back inside and made some excuse to drive to grandma's (11 miles away)."

SNAKES

Alex, 24

I think I'm the only nature photographer who is terrified of snakes.

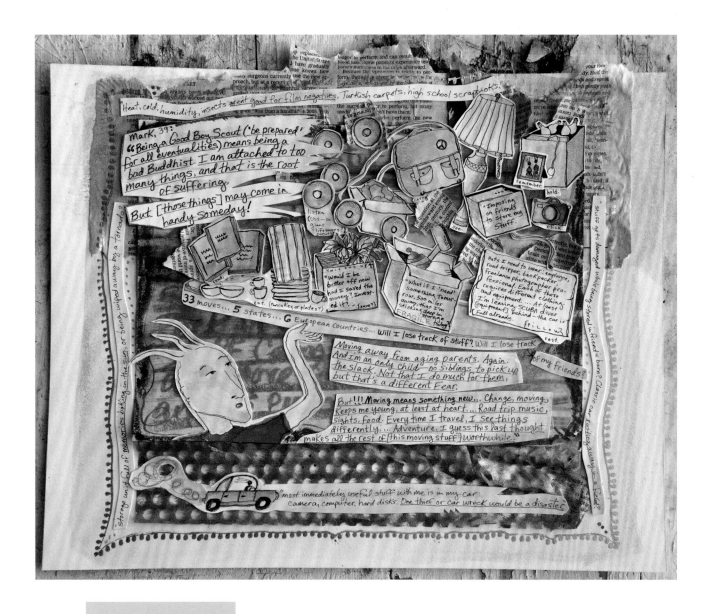

CLUTTER

Mark, 39

I am attached to too many things, and that is the root of suffering.

DOLLS
Zach, 15

My Grammy has a lot of dolls.... [They] are very old and so real looking.
When I am walking around the house, it feels like the eyes are following me.

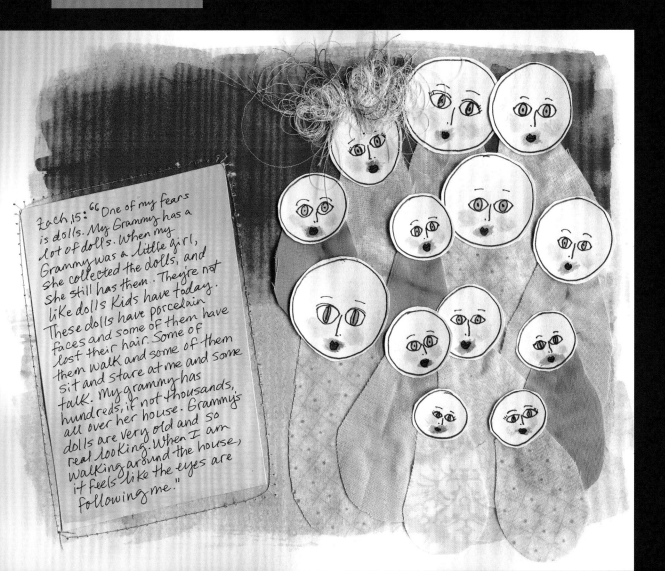

Zach, 15: "One of my fears is dolls. My Grammy has a lot of dolls. When my Grammy was a little girl, she collected the dolls, and she still has them. They're not like dolls Kids have today. These dolls have porcelain faces and some of them have lost their hair. Some of them walk and some of them sit and stare at me and some talk. My grammy has hundreds, if not thousands, all over her house. Grammy's dolls are very old and so real looking. When I am walking around the house, it feels like the eyes are following me."

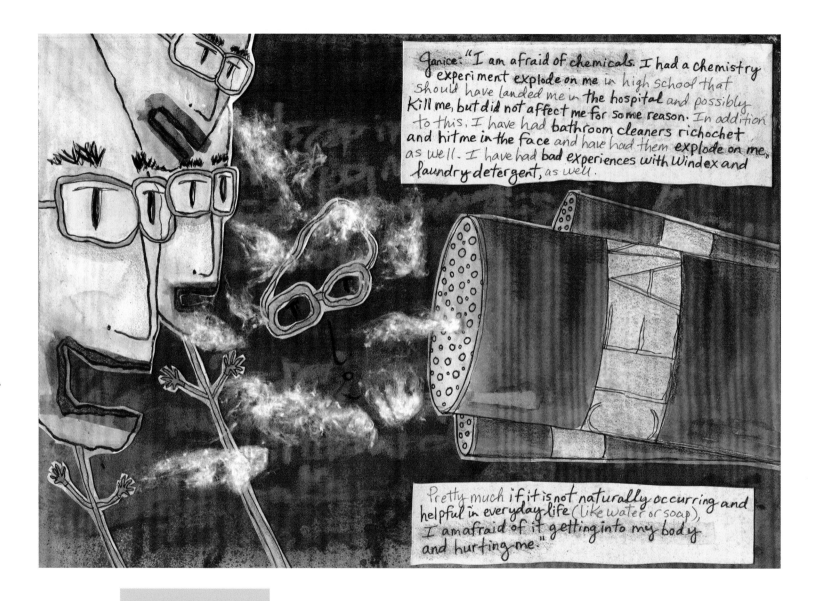

CHEMICALS
Janice

I had a chemistry experiment explode on me in high school
that should have landed me in the hospital...

I'm afraid of jaywalking. It's not the way I want to go out.

Annie, 21: "I'm afraid of *Jaywalking*. It's not the way I want to go out. Of all the ways you could die, it's one of the stupidest, in my opinion. And I'd hate for my parents to get a phone call one day, just saying, 'your daughter died because she got hit by a car because she didn't wait for the crosswalk.'"

"Do you j-walk?" "Sometimes, when I'm in a rush. But it has to be Very Coast Is Clear."

We're trying to put our 3-year-old into swim lessons, because we have an ultra-brave boy who doesn't really have boundaries about what is safe and what's not. And so, he just jumps off the edge.

B, 33: "Swimming is a lifeskill. So we're trying to put our 3 year old into swim lessons, because we have an ultra-brave boy who doesn't really have boundaries about what is safe and what's not.

And so, he just jumps off the edge.

And he'll push you away to not catch him—but he can't swim, yet. We need to keep going to swim lessons because I'm worried that someday he is going to just decide he's going to go for it and jump off the side of the pool."

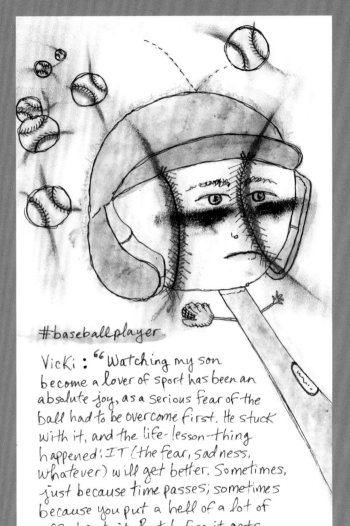

#baseballplayer

Vicki: "Watching my son become a lover of sport has been an absolute joy, as a serious fear of the ball had to be overcome first. He stuck with it, and the life-lesson-thing happened: IT (the fear, sadness, whatever) will get better. Sometimes, just because time passes; sometimes because you put a hell of a lot of effort into it. But, before it gets better, you keep your chin up and cheer your teammates on.

Well done, son."

Watching my son become a lover of sport has been an absolute joy, as a serious fear of the ball had to be overcome first.

Charlee, 15: "I Hate Nails on a blackboard—it crunches up my ears and makes me squint. It sends shivers down my spine. It makes me look at my nails and think it's happened to them, when they drag it across a wall or anything with a rough texture, it's like they are scratching my brains out!"

FEAR

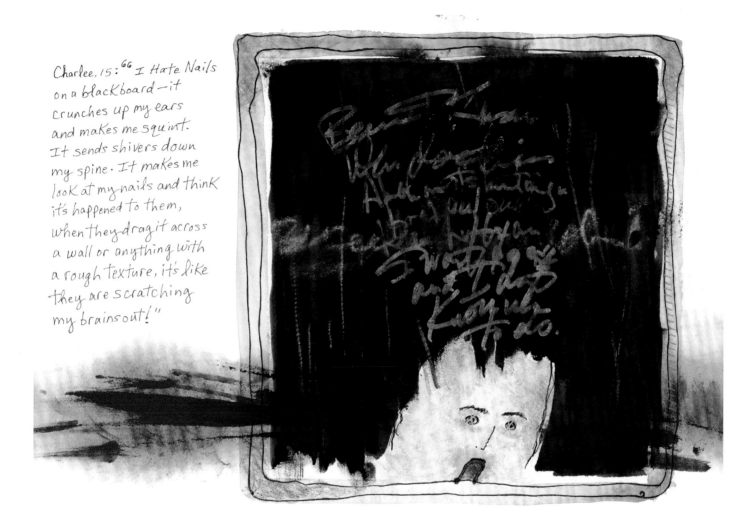

CHALKBOARD
Charlee, 15

I hate nails on a blackboard.... It sends shivers down my spine.

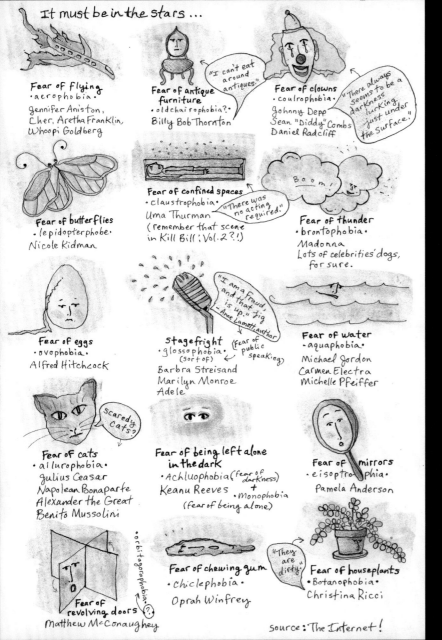

It must be in
the stars...

Johnny Depp's (alleged)
fear of clowns:

There always seems
to be a darkness lurking
just under the surface.

FINDING HAPPINESS

A I'm terrified I'll never learn to be happy.

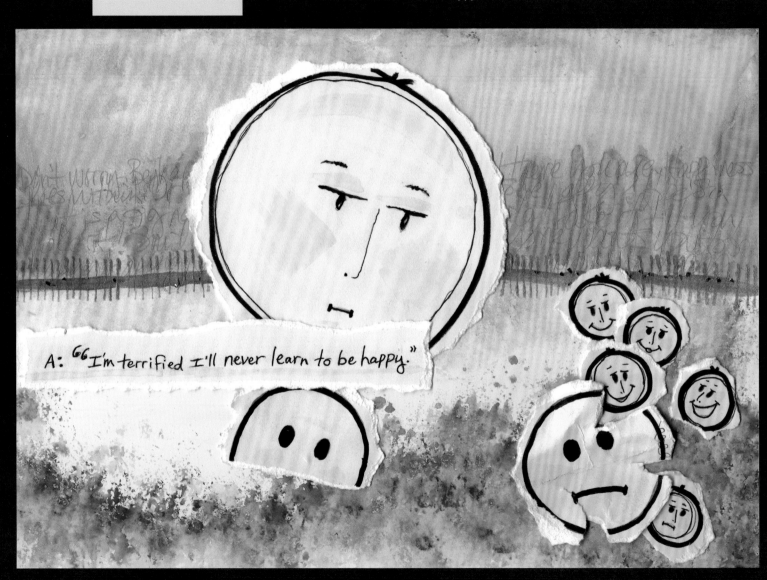

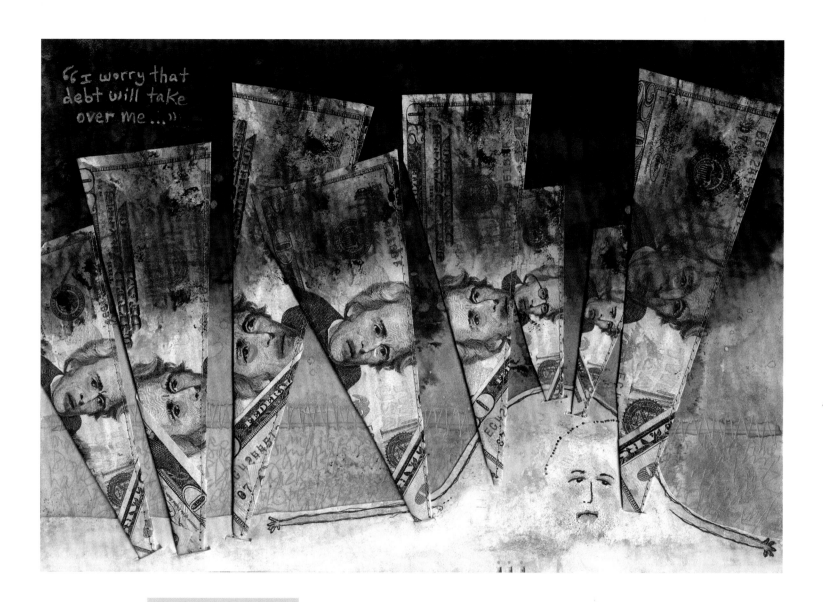

DEBT
Anonymous

I worry that debt will take over me...

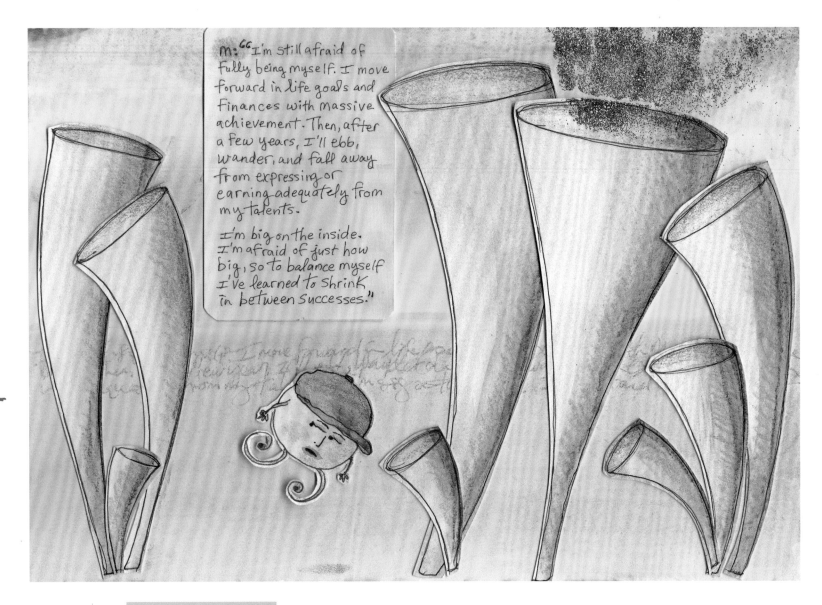

SUCCESS

M

I'm still afraid of fully being myself.

Anonymous, 14 Getting low grades and failing school.

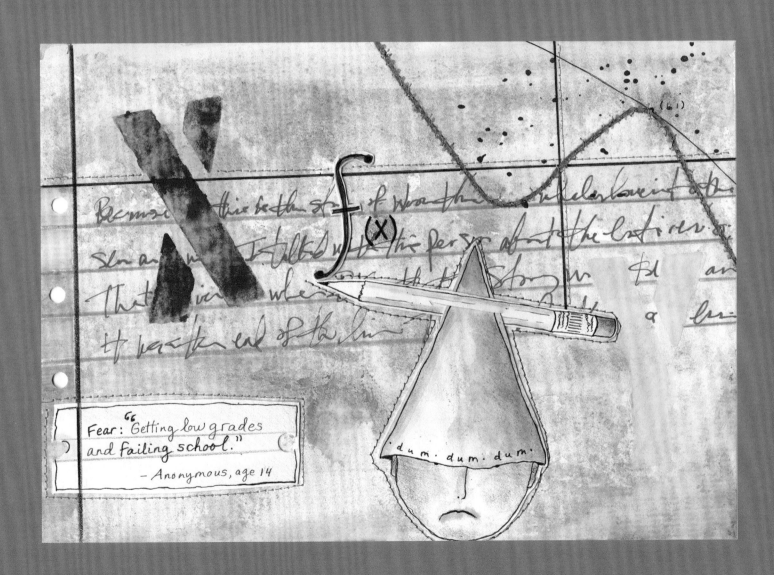

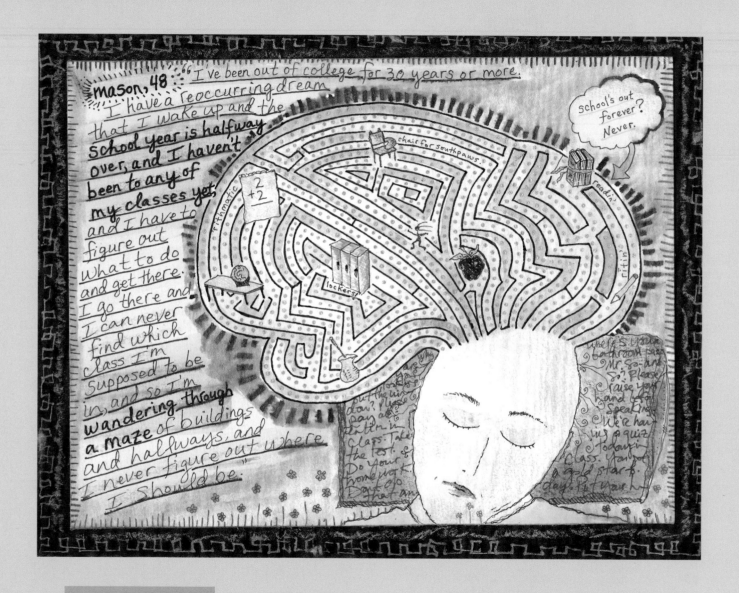

I have a reoccurring dream that I wake up and the school year is halfway over, and I haven't been to any of my classes yet…. I'm wandering through a maze of buildings and hallways, and I never figure out where I should be.

TEST NIGHTMARES
Jane, 42

Showing up for a test, but [I] haven't gone to class for the whole quarter or semester.

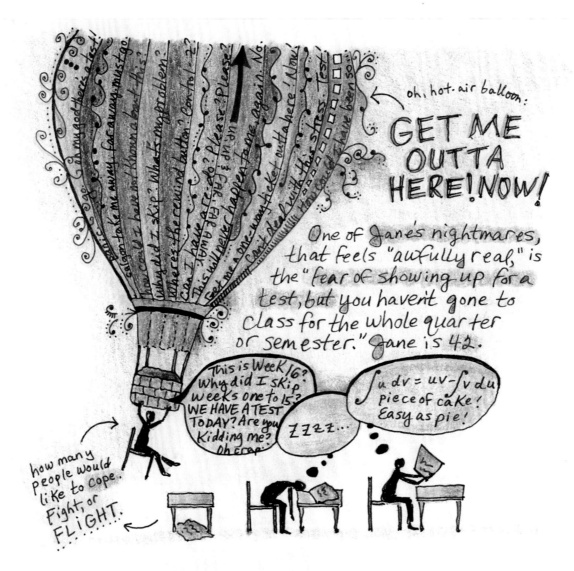

Hannah I'm 18, and I'm afraid of being alone.

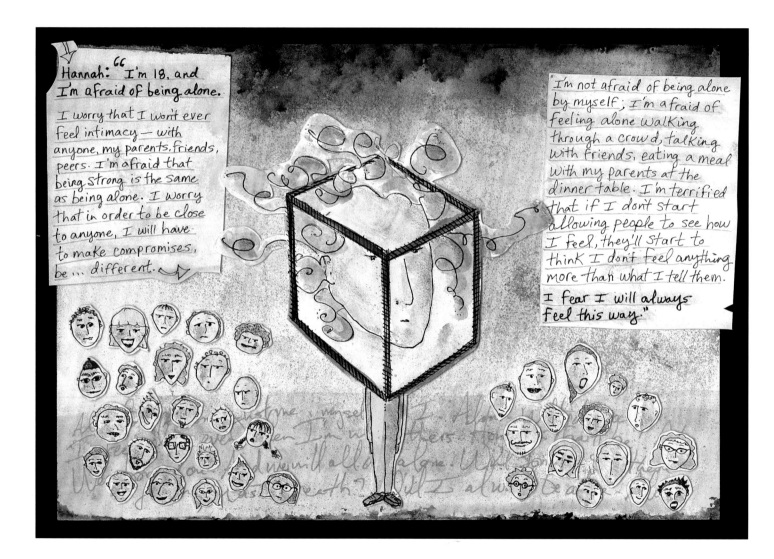

Gabriela, 15: "I don't know what I'm afraid of... At first, the answer was clear: gluttony. But really, am I truly afraid of becoming fat? No, not really. And the more I think about it, it's obvious that fat isn't really my fear; food is my outlet, and I get worried that like everything else, I'll overdo it. I think that's what I'm really afraid of. I'm afraid of losing control: of my diet, grades, ambition.

And that's also why I'm afraid of leaving high school and picking a job; in ten years, I don't want to hate the career that I choose, lose control of my ambitions and end up on the side of the road dreaming of what I once was and aspired to be.

It's this need to maintain control that affects my friendships and prevents relationships. I don't enter anything without an escape hatch, and if I truly fall in love with someone and lose sight of my goals, then...

Then I don't know.

But that can't happen.

So it never will."

LOSING CONTROL
Gabriela, 15

I don't know what I'm afraid of.... At first, the answer was clear: gluttony. But really, am I truly afraid of becoming fat? No, not really.... I'm afraid of losing control

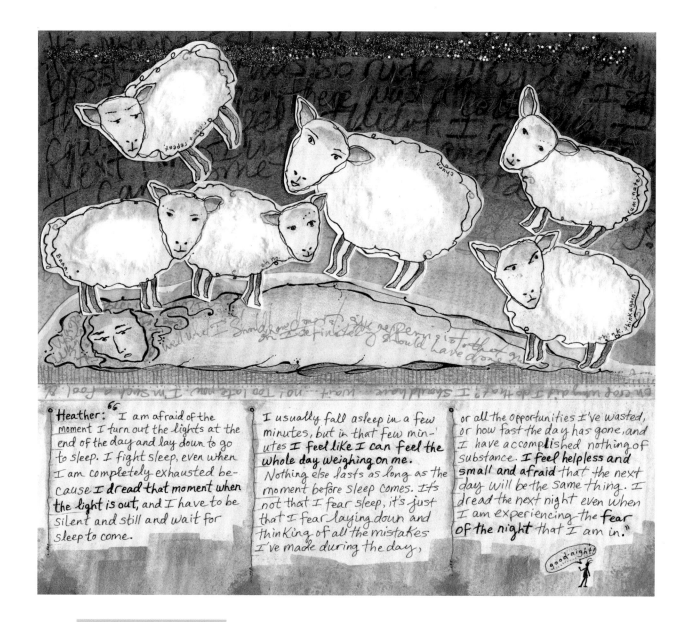

Heather: " I am afraid of the moment I turn out the lights at the end of the day and lay down to go to sleep. I fight sleep, even when I am completely exhausted because I dread that moment when the light is out, and I have to be silent and still and wait for sleep to come.

I usually fall asleep in a few minutes, but in that few minutes I feel like I can feel the whole day weighing on me. Nothing else lasts as long as the moment before sleep comes. It's not that I fear sleep, it's just that I fear laying down and thinking of all the mistakes I've made during the day, or all the opportunities I've wasted, or how fast the day has gone, and I have accomplished nothing of substance. I feel helpless and small and afraid that the next day will be the same thing. I dread the next night even when I am experiencing the fear of the night that I am in."

good-night!

SLEEP
Heather

I am afraid of the moment I turn out the lights at the end of the day and lay down to go to sleep.

A little trip to the bathroom in the dark, and I have to half-sprint back to my bed out of fear that something is going to drag me backwards.

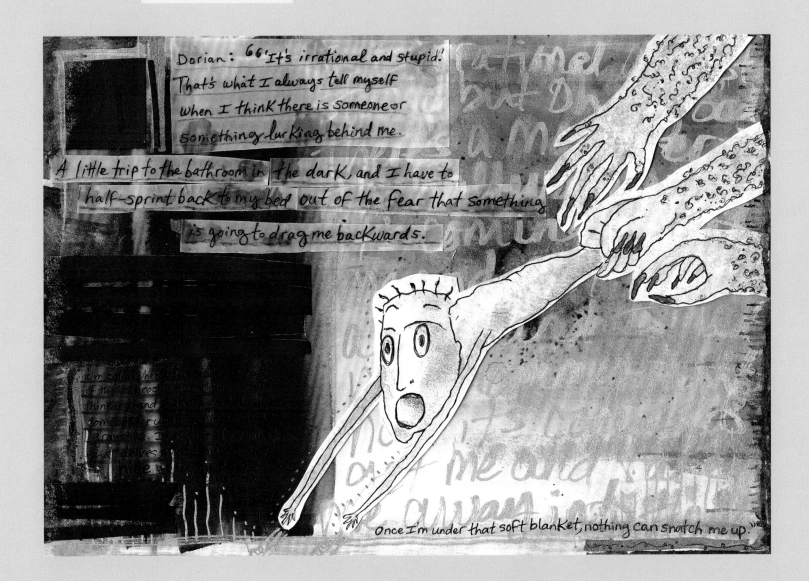

Dorian: "'It's irrational and stupid.' That's what I always tell myself when I think there is someone or something lurking behind me.

A little trip to the bathroom in the dark, and I have to half-sprint back to my bed out of the fear that something is going to drag me backwards.

Once I'm under that soft blanket, nothing can snatch me up."

WRONGFULLY ACCUSED
Jody, 49

I always get the feeling that I'm being watched, and that there's a security guard that's going to trail me and think that I shoplifted something...

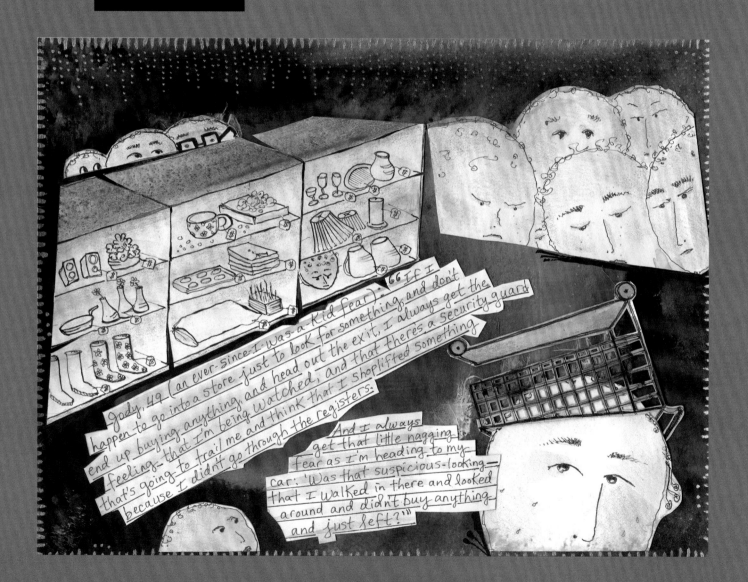

A 50-year-old man who wishes to remain anonymous...

66 When I was in college, I worked for Disney in Orlando. When you work at Disney, you dress in costuming areas in tunnels below the park, and then you walk up to your job site through some non-descript doors—so you know where all these entrances are to the tunnel areas.

"And after I stopped working there, years later, I wanted to impress my girlfriend at the time, and we were walking around the park, and I showed her where one of these nondescript doors was. We walked downstairs, and there happened to be a security guard there. There almost never was when I worked there. He caught sight of us and started questioning us and realized that I didn't work there.

"And the understanding is, when you stop working there, you, of course, would never go down in the tunnels. So we were taken upstairs into an office area, our pictures were taken, we were put in a file, and we were escorted to the front gate of the park—and told that because of our indiscretion, we were banned for life from Disney World.

"Over the years, I've wanted to take my kids to Disney World, so I've done it, but I've been very fearful of being told, 'OK, we're going to arrest you now because you've been banned for life, and you came back to the park.'"

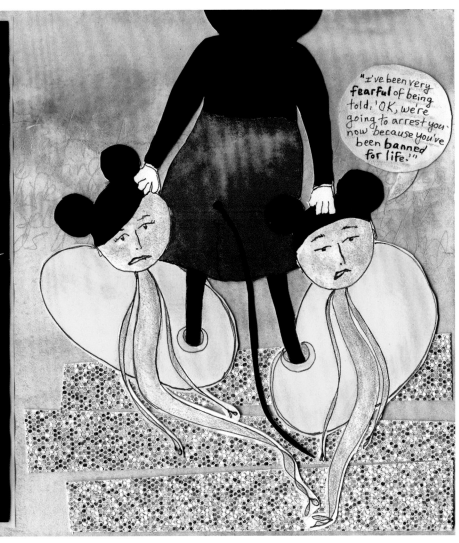

DISNEY
Anonymous, 50

Over the years, I've wanted to take my kids to Disney World...but I've been very fearful of being told, "OK, we're going to arrest you now because you've been banned for life, and you came back to the park."

DISAGREEMENT
Joni, 54

When I was younger, I took on a role of establishing harmony in my family, by not expressing my needs. It's a pattern I have developed—a kind of this faux harmony....

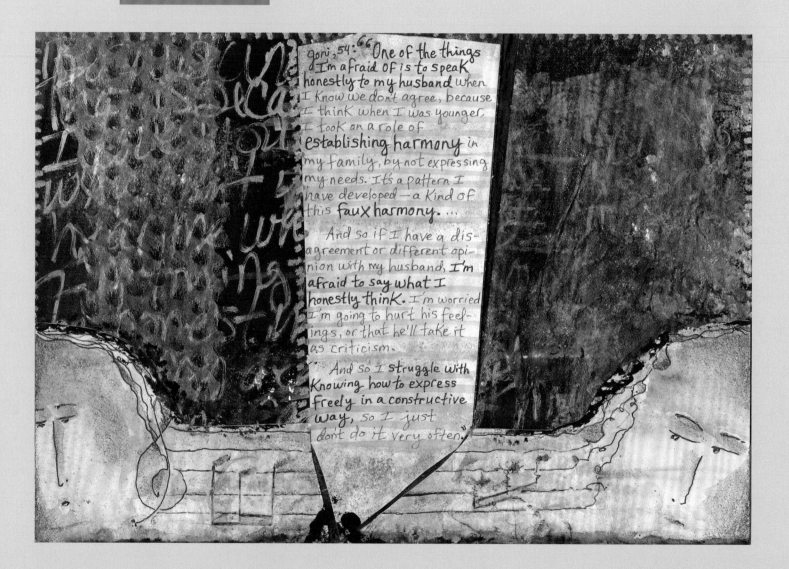

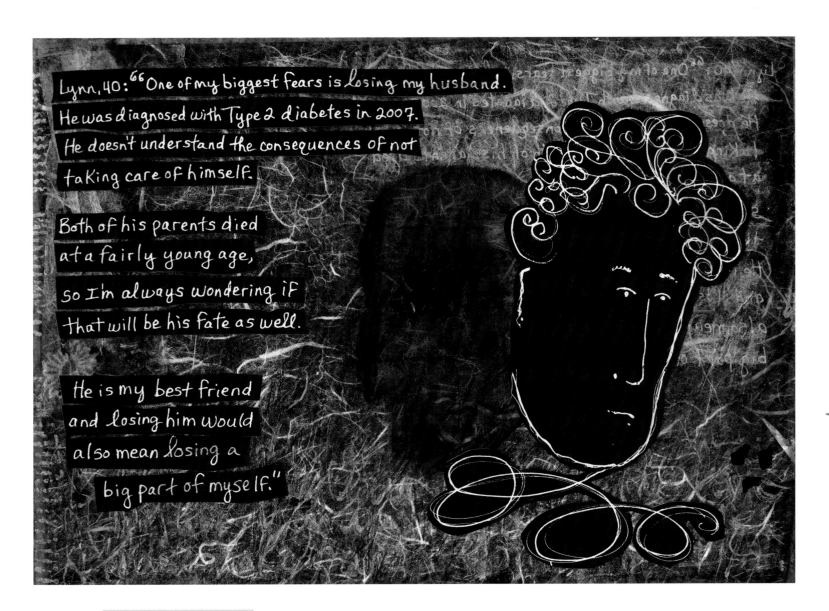

Lynn, 40: "One of my biggest fears is losing my husband. He was diagnosed with Type 2 diabetes in 2007. He doesn't understand the consequences of not taking care of himself.

Both of his parents died at a fairly young age, so I'm always wondering if that will be his fate as well.

He is my best friend and losing him would also mean losing a big part of myself."

LOSING PARTNER

Lynn, 40

One of my biggest fears is losing my husband. He was diagnosed with Type 2 diabetes in 2007. He doesn't understand the consequences of not taking care of himself.... He is my best friend and losing him would also mean losing a big part of myself.

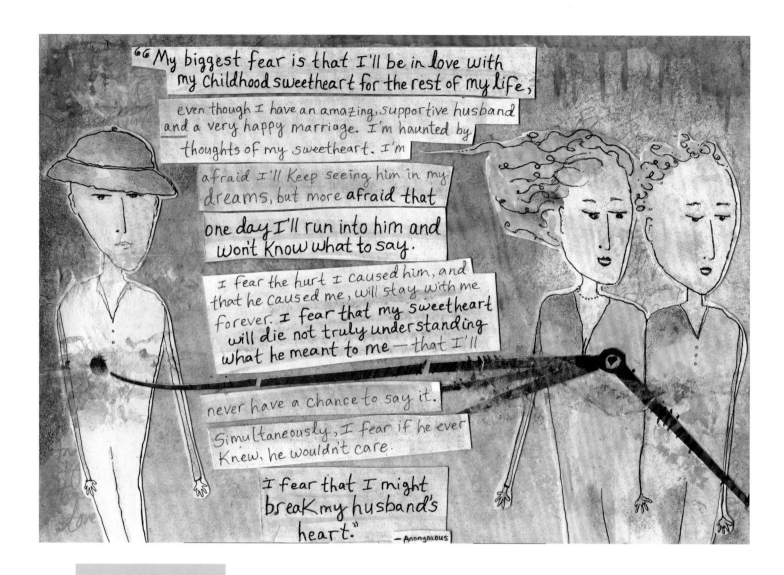

"My biggest fear is that I'll be in love with my childhood sweetheart for the rest of my life, even though I have an amazing, supportive husband and a very happy marriage. I'm haunted by thoughts of my sweetheart. I'm afraid I'll keep seeing him in my dreams, but more afraid that one day I'll run into him and won't know what to say. I fear the hurt I caused him, and that he caused me, will stay with me forever. I fear that my sweetheart will die not truly understanding what he meant to me — that I'll never have a chance to say it. Simultaneously, I fear if he ever knew, he wouldn't care. I fear that I might break my husband's heart."

—Anonymous

BREAKING HUSBAND'S HEART
Anonymous

My biggest fear is that I'll be in love with my childhood sweetheart for the rest of my life, even though I have an amazing, supportive husband and a very happy marriage. I'm haunted by thoughts of my sweetheart.... I fear that I might break my husband's heart.

I don't want to fall out of love with my significant other down the road, and I guess I fear divorce because how can you prepare for that?

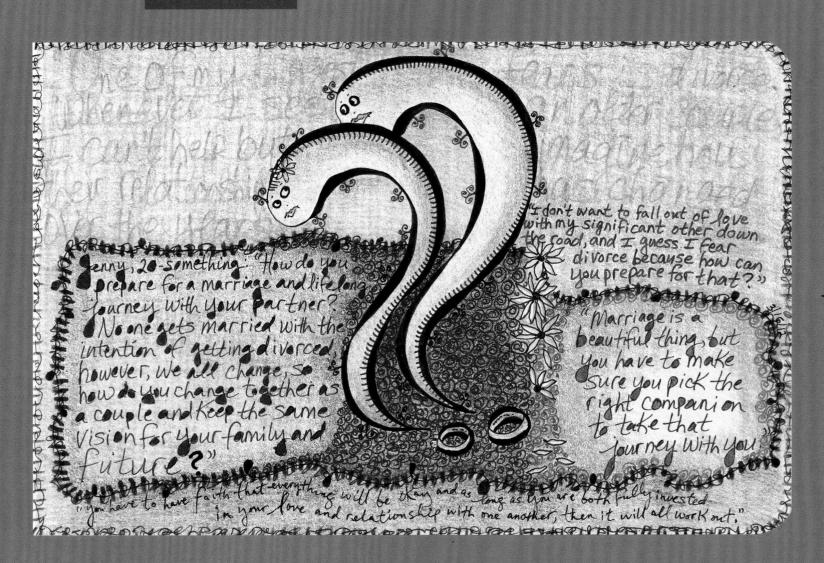

Jenny, 20-something: "How do you prepare for a marriage and lifelong journey with your partner? No one gets married with the intention of getting divorced, however, we all change, so how do you change together as a couple and keep the same vision for your family and future?"

"I don't want to fall out of love with my significant other down the road, and I guess I fear divorce because how can you prepare for that?"

"Marriage is a beautiful thing, but you have to make sure you pick the right companion to take that journey with you."

"You have to have faith that everything will be okay and as long as you are both fully invested in your love and relationship with one another, then it will all work out."

For more than a year I woke up with a terrible fear that I would lose the ability to see and be with our girls.... It was worse than the fear of death.

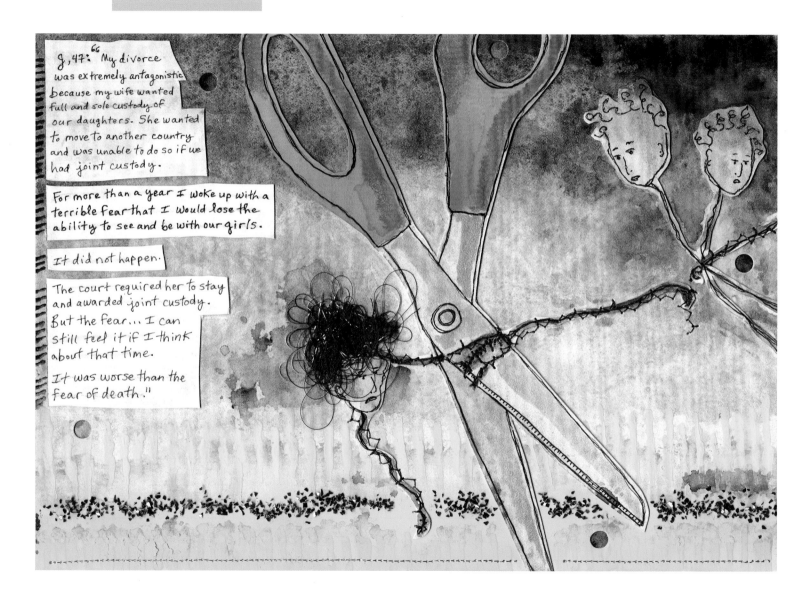

J, 47: "My divorce was extremely antagonistic because my wife wanted full and sole custody of our daughters. She wanted to move to another country and was unable to do so if we had joint custody.

For more than a year I woke up with a terrible fear that I would lose the ability to see and be with our girls.

It did not happen.

The court required her to stay and awarded joint custody. But the fear... I can still feel it if I think about that time.

It was worse than the fear of death."

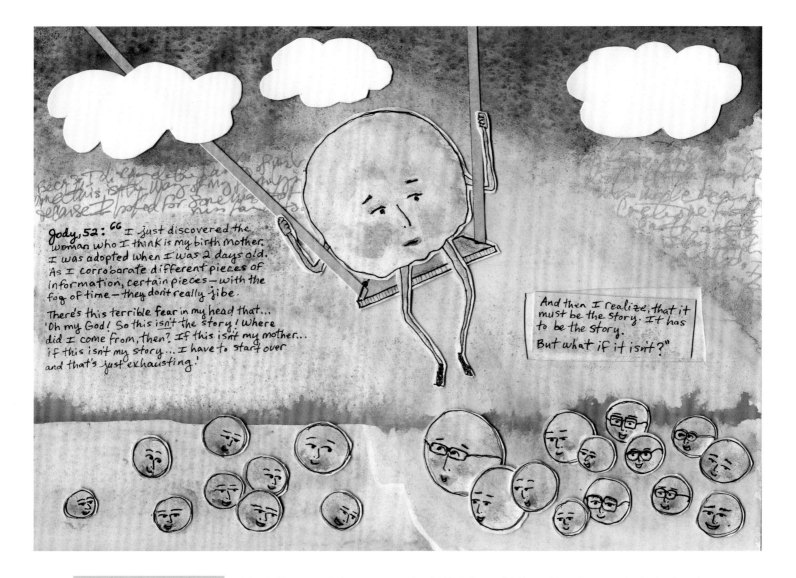

BIRTH FAMILY STORY
Jody, 52

I just discovered the woman who I think is my birth mother. I was adopted when I was two days old. As I corroborate different pieces of information, certain pieces—with the fog of time—they don't really jibe. There's this terrible fear in my head that…"Oh, my God! So this isn't the story!"

My fear is that one day, when I start to have children, that I won't be a good father.

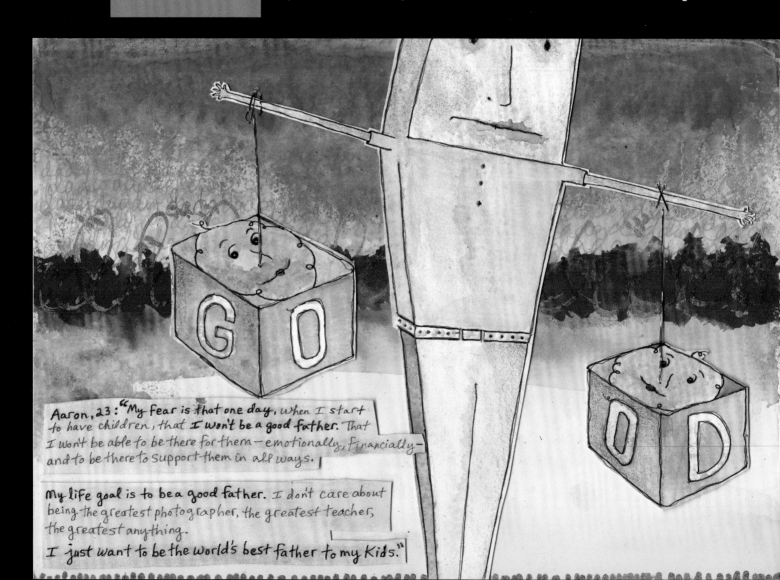

Aaron, 23: "My fear is that one day, when I start to have children, that **I won't be a good father.** That I won't be able to be there for them — emotionally, financially — and to be there to support them in all ways.

My life goal is to be a good father. I don't care about being the greatest photographer, the greatest teacher, the greatest anything.

I just want to be the world's best father to my kids."

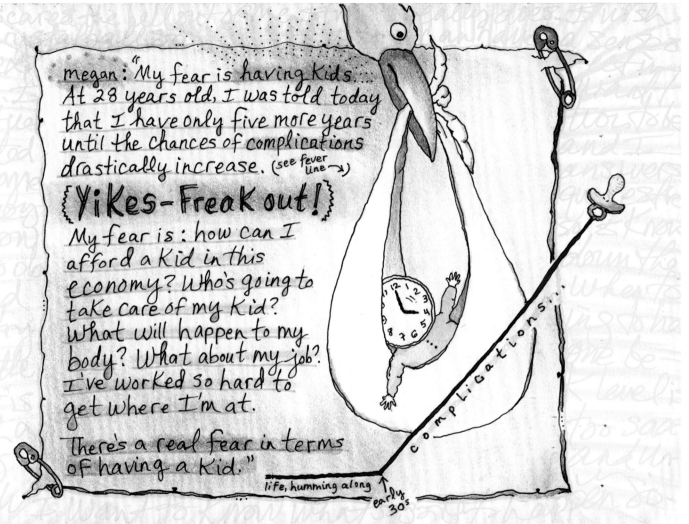

megan: "My fear is having kids... At 28 years old, I was told today that I have only five more years until the chances of complications drastically increase. (see fever line →)

{ Yikes – Freak out! }

My fear is: how can I afford a kid in this economy? Who's going to take care of my kid? What will happen to my body? What about my job? I've worked so hard to get where I'm at.

There's a real fear in terms of having a kid."

life, humming along early 30s

complications...

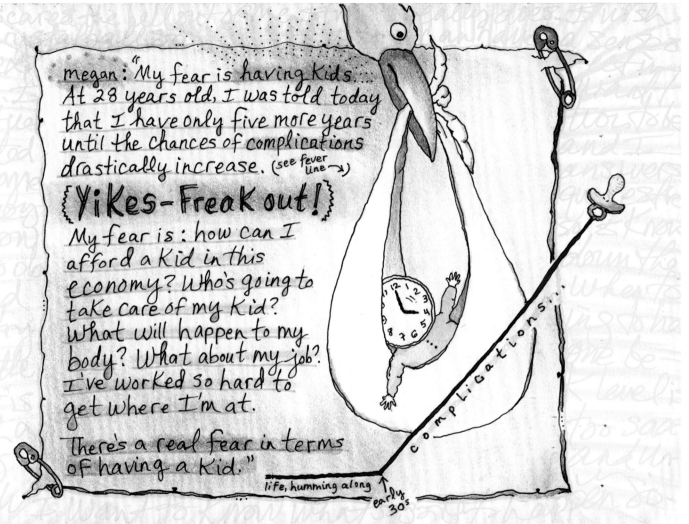

HAVING CHILDREN

Megan, 28

How can I afford a kid in this economy? Who's going to take care of my kid? What will happen to my body? What about my job?

DIGITAL LIFE
Julie, 50-something

I have this nagging fear that I'll always feel like I'm being left behind in the digital dust—because I'll never, ever be able to catch up.

SOCIAL MEDIA POSERS
Nick, 25

I have this fear that if I die, all my social media accounts will still be up and active and [someone will] start posting as me–and someone will get on them [and] diminish my personas.

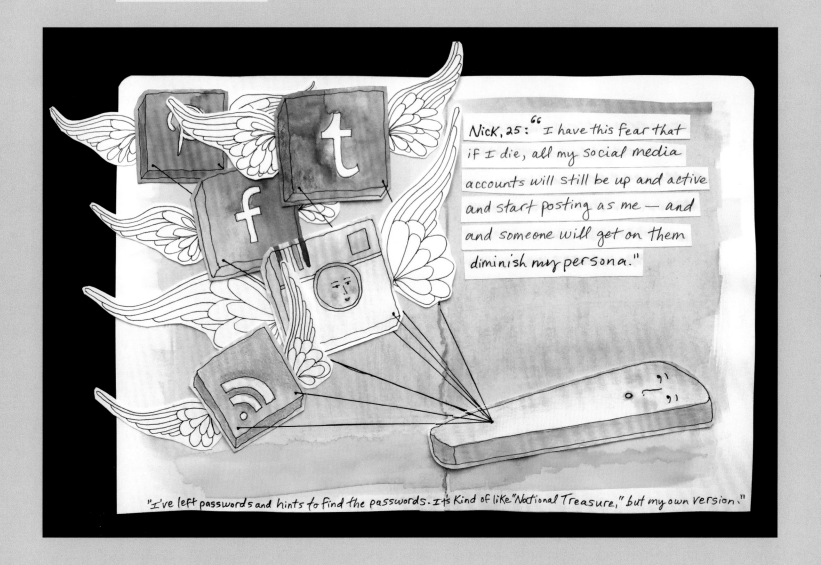

Nick, 25: "I have this fear that if I die, all my social media accounts will still be up and active and start posting as me — and and someone will get on them diminish my persona."

"I've left passwords and hints to find the passwords. It's kind of like "National Treasure," but my own version."

I couldn't deal with checks, credit cards, [and] legal documents of any kind, for fear that my palms would sweat and my hands would shake, and I would be denied whatever it was I was trying to commit myself to. Was it doubt about my own identity? A feeling of unworthiness?

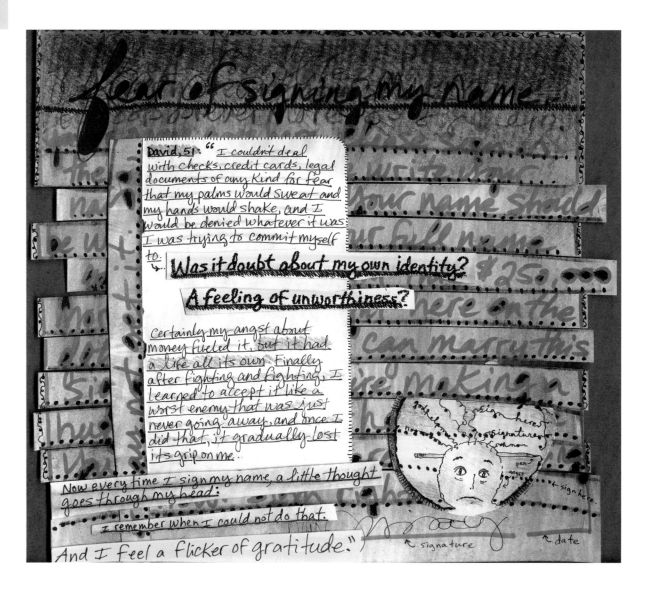

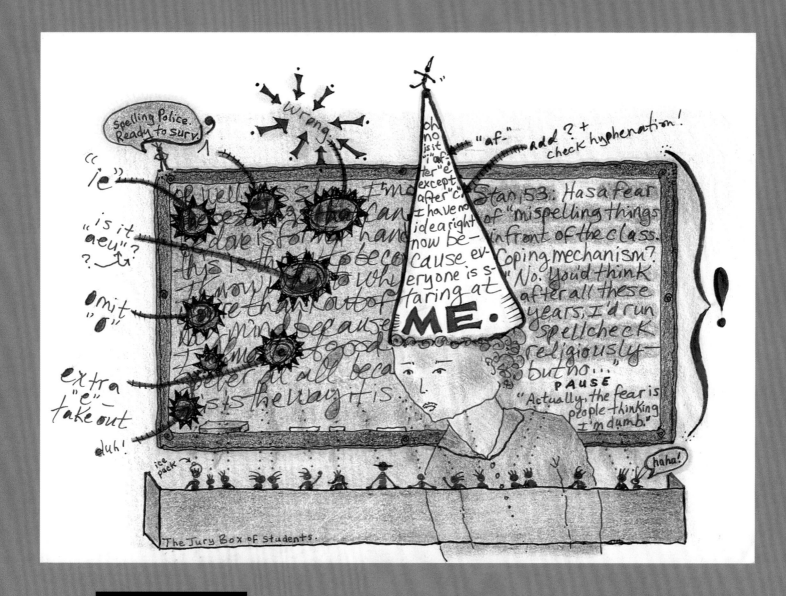

SEEN AS STUPID
Stan, 53

Fear of misspelling things in front of the class.... Actually, the fear is people thinking I'm dumb.

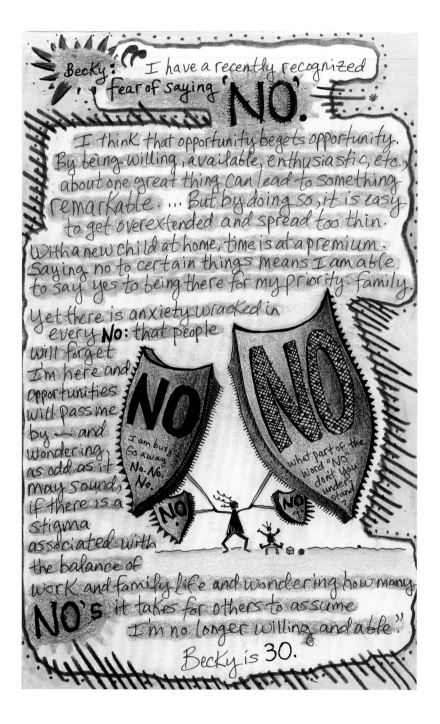

SAYING "NO"
Becky, 30

There is anxiety wracked
in every "NO."

NOT BEING HEARD

Marlene, 54

My fear is not being heard or understood. So often people are ready to jump in and tell you what they think rather than listen.

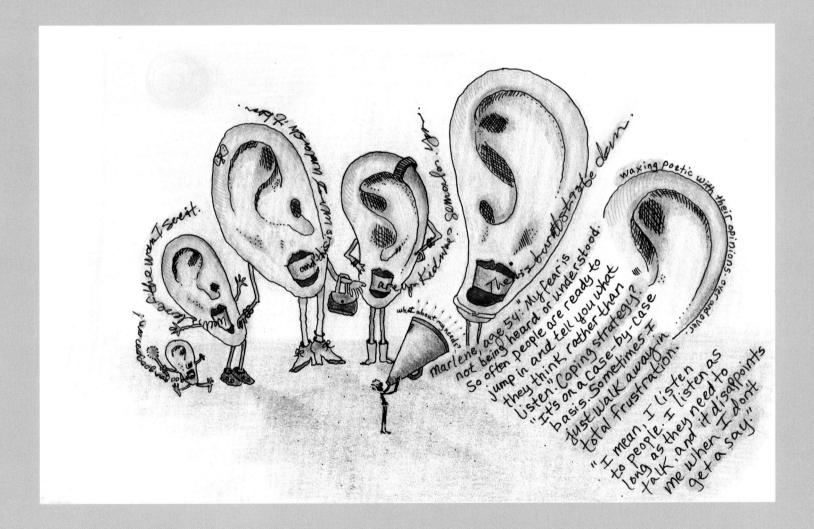

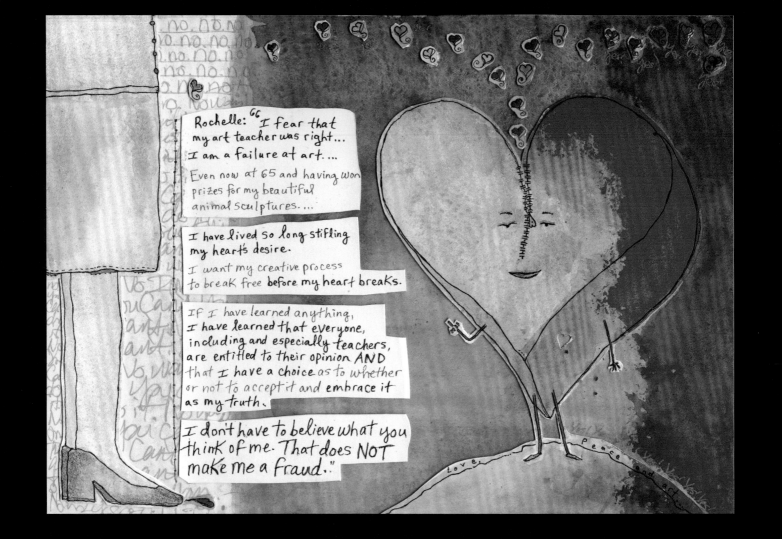

Rochelle: "I fear that my art teacher was right... I am a failure at art. ...

Even now at 65 and having won prizes for my beautiful animal sculptures. ...

I have lived so long stifling my heart's desire.

I want my creative process to break free before my heart breaks.

If I have learned anything, I have learned that everyone, including and especially teachers, are entitled to their opinion AND that I have a choice as to whether or not to accept it and embrace it as my truth.

I don't have to believe what you think of me. That does NOT make me a fraud."

Love

Peace and art

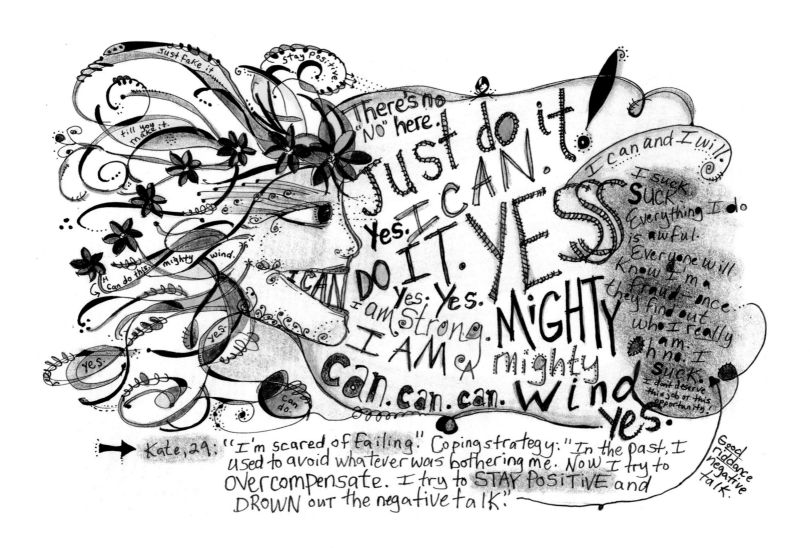

**FAILURE
AT LIFE**

Kate, 29 I'm scared of failing.

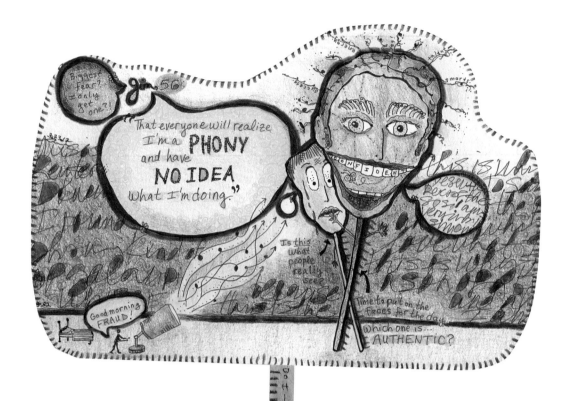

FEAR

BEING A PHONY

Jim, 56

That everyone will realize I'm a phony and have no idea what I'm doing.

PERFECTION
Lizzy

I fear that judgment will never let me live a normal life; happy and free from the confines of my internal embarrassment.... I fear perfection.

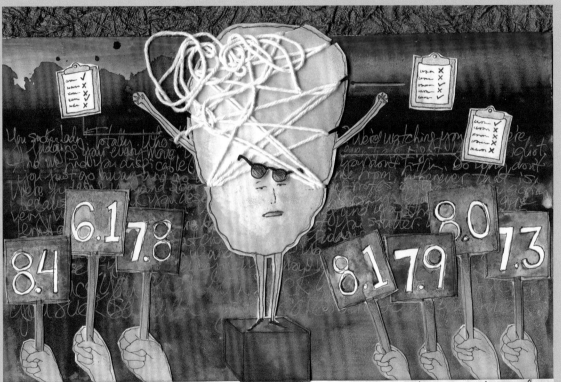

Lizzy: " I fear the judgment and ridicule based on any poor performance. I fear that my referral to my everyday life, day-to-day as a theatrical performance in which I must achieve the highest approval rating, might suggest I am a little unbalanced. I fear that my hypersensitivity to judgment will eventually completely suffocate my creative process.

I fear that judgment will never let me live a normal life; happy and free from the confines of my internal embarrassment at each less-than-perfect act, project, clothing choice, grammar, pronun-nun-cia-tion. Shoot, I stuttered. Let's start over, again. I fear perfection. "

PERFECT PLACE

Anonymous

The proverbial "grass is always greener" leaves me anxious and confused as to where I would be the happiest.

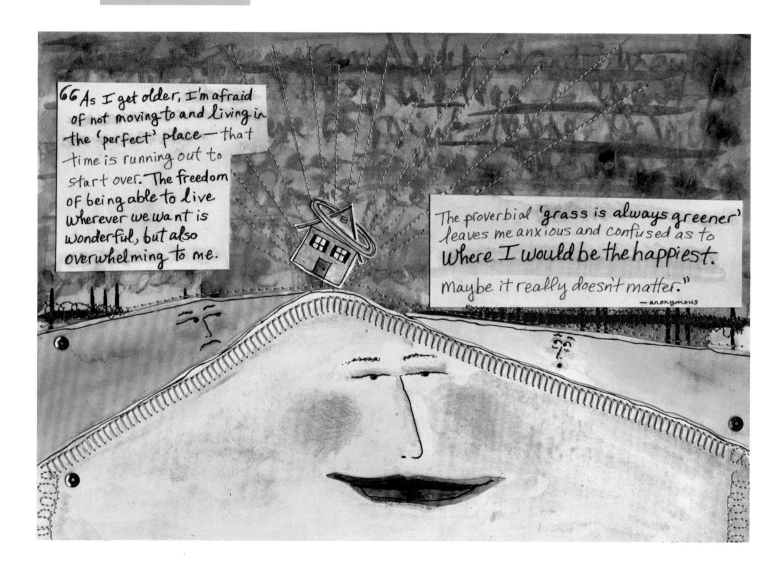

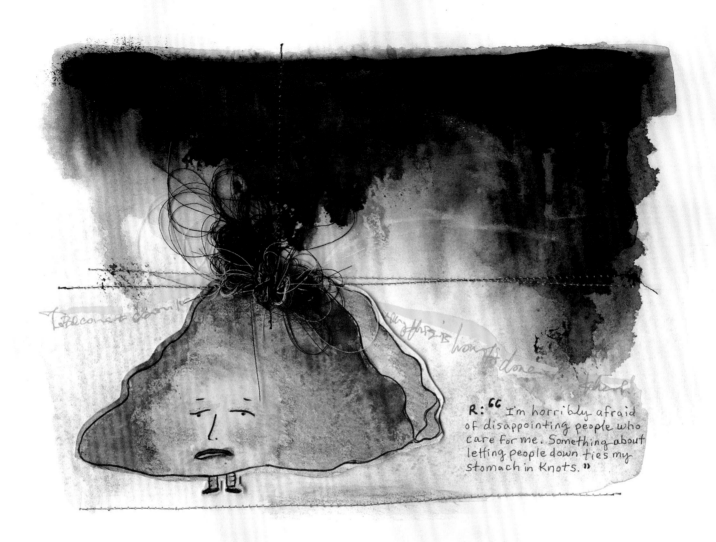

R: "I'm horribly afraid of disappointing people who care for me. Something about letting people down ties my stomach in knots."

DISAPPOINTING PEOPLE

R

I'm horribly afraid of disappointing people who care for me.

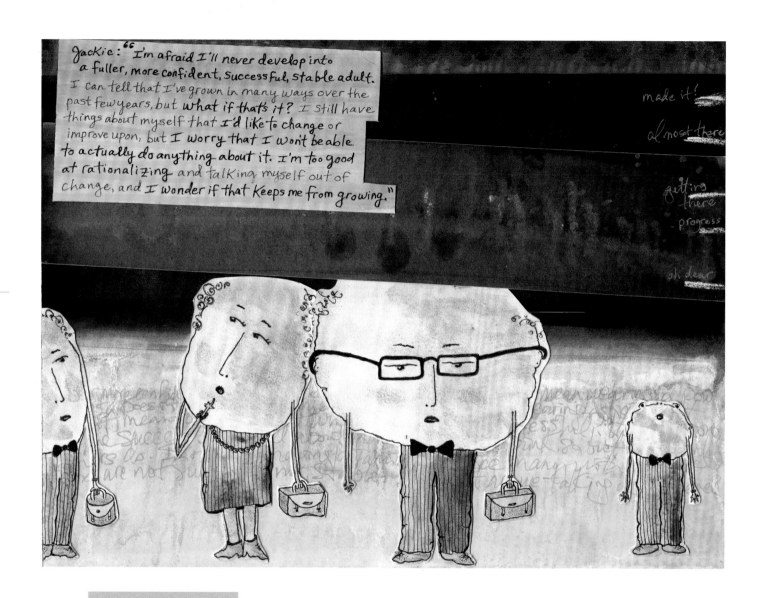

INSTABILITY
Jackie

I'm afraid I'll never develop into a fuller, more confident, successful, stable adult.

WORKAHOLISM
Anonymous

I'm so scared of working so hard that I forget to live.

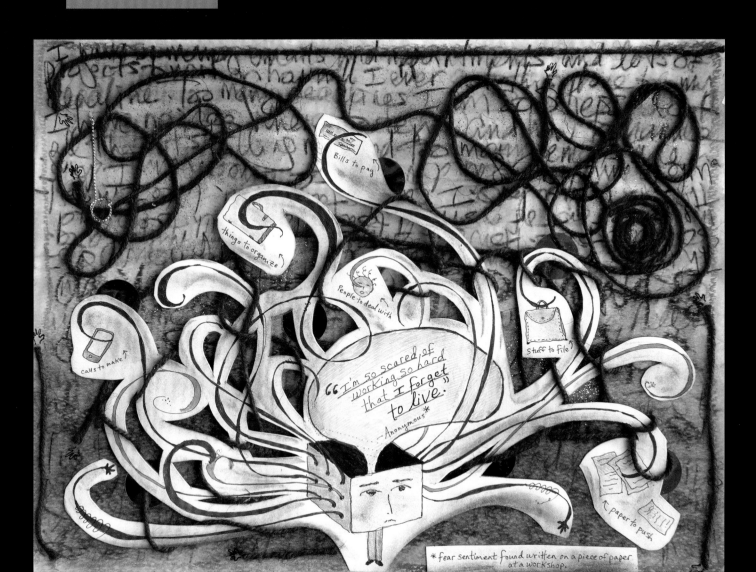

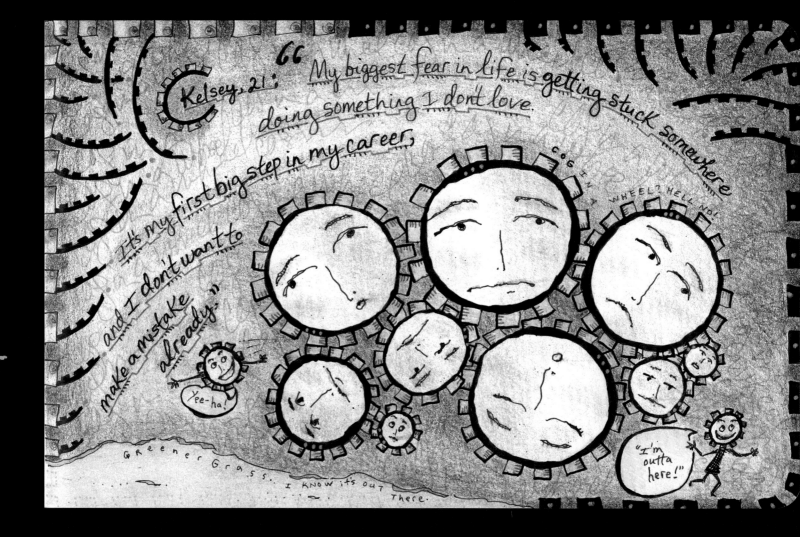

STUCK IN A JOB
Kelsey, 21

My biggest fear in life is getting stuck somewhere doing something I don't love.

NOT BEING IN THE MOMENT
Terry, 64

My biggest fear, I think, is not being fulfilled this lifetime. And by that I mean not having time to be with myself; not having time to slow down to the moment.

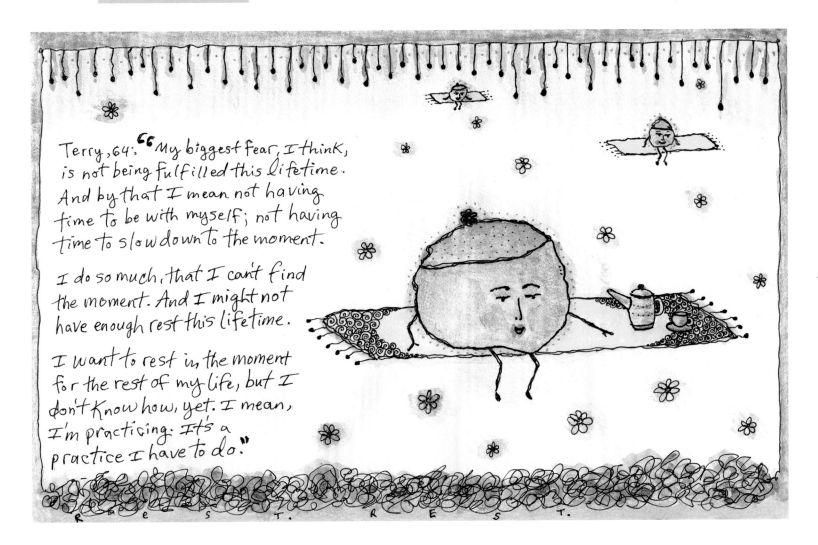

Terry, 64: "My biggest fear, I think, is not being fulfilled this lifetime. And by that I mean not having time to be with myself; not having time to slow down to the moment.

I do so much, that I can't find the moment. And I might not have enough rest this lifetime.

I want to rest in the moment for the rest of my life, but I don't know how, yet. I mean, I'm practicing: It's a practice I have to do."

FINDING PASSION
K, 20

I fear that I will never find my passion and never feel fulfilled in life.... I don't want to be miserable in this life.

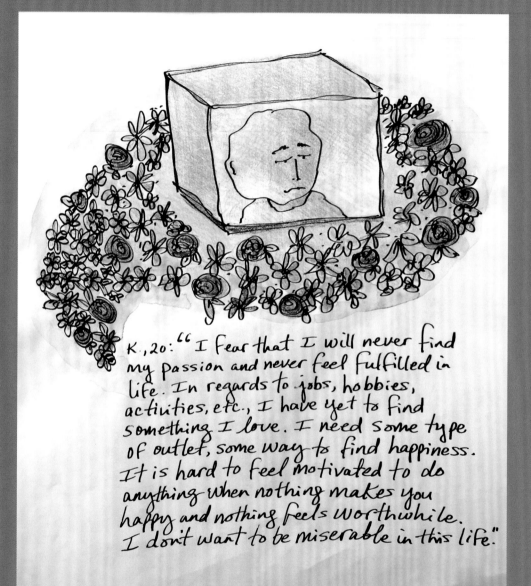

K., 20: " I fear that I will never find my passion and never feel fulfilled in life. In regards to jobs, hobbies, activities, etc., I have yet to find something I love. I need some type of outlet, some way to find happiness. It is hard to feel motivated to do anything when nothing makes you happy and nothing feels worthwhile. I don't want to be miserable in this life."

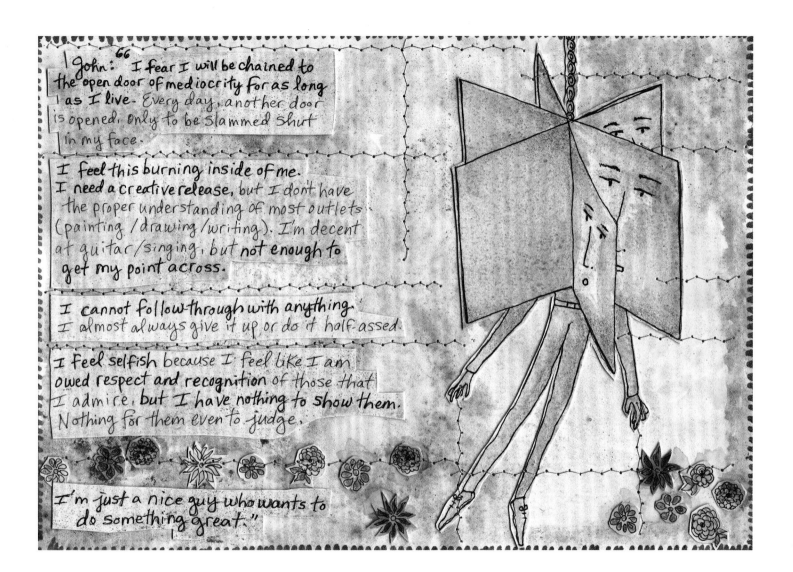

85

FEAR

MEDIOCRITY

John

I fear I will be chained to the open door of mediocrity for as long as I live.

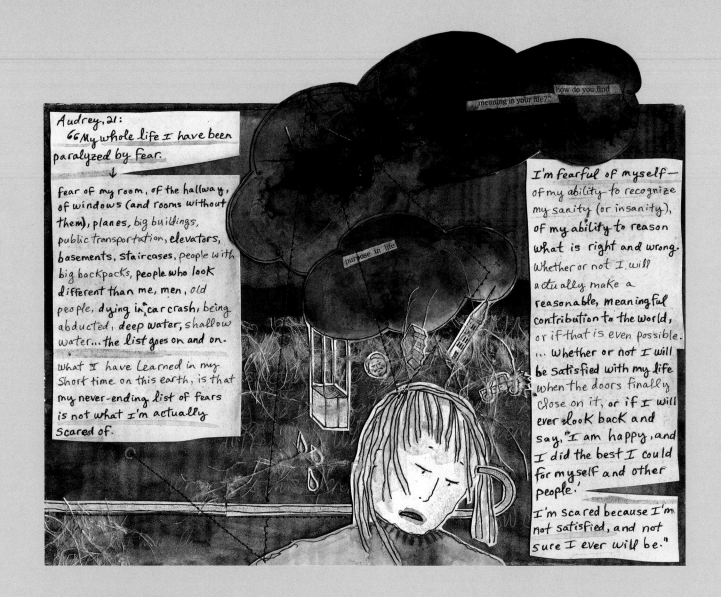

LIFE PARALYSIS
Audrey, 21

My whole life I have been paralyzed by fear. ...What I have learned in my short time on this earth, is that my never-ending list of fears is not what I'm actually scared of. I'm fearful of myself...

PURPOSE

Meg,
20-something

I am not afraid of never finding a solution to what life is, but rather afraid of finding peace that we will all never understand.

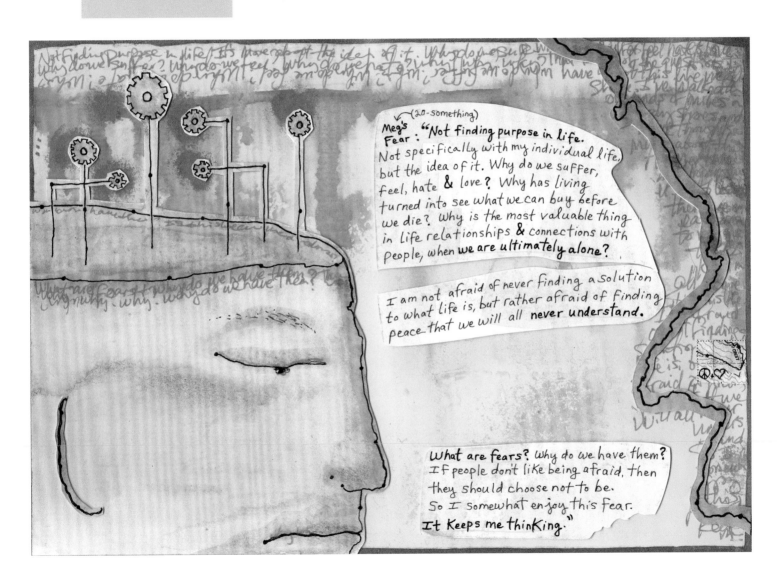

I don't like being too comfortable. So, for example, I don't sleep on a bed. I tend to barely ever sit in furniture.... I fear being sedentary.

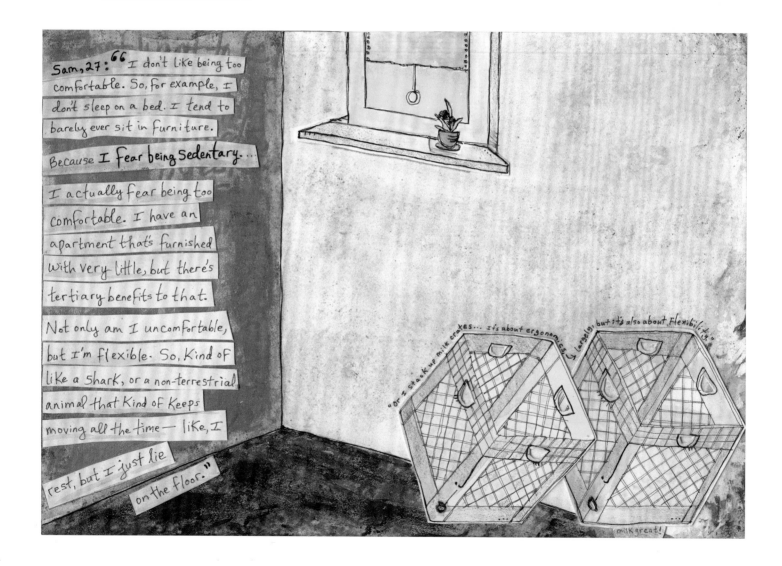

Sam, 27: "I don't like being too comfortable. So, for example, I don't sleep on a bed. I tend to barely ever sit in furniture.

Because I fear being sedentary...

I actually fear being too comfortable. I have an apartment that's furnished with very little, but there's tertiary benefits to that. Not only am I uncomfortable, but I'm flexible. So, kind of like a shark, or a non-terrestrial animal that kind of keeps moving all the time — like, I rest, but I just lie on the floor."

"Or I stack up milk crates... It's about ergonomics," (angel?) but it's also about flexibility."

milk great!

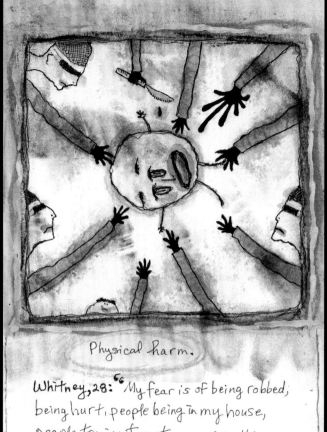

Physical harm.

Whitney, 28: "My fear is of being robbed, being hurt, people being in my house, people trying to get me — anything associated with any sort of physical harm. I'm pretty sure I watched too much 'America's Most Wanted' and 'Cops' as a child, and that's why I went to bed having too many nightmares about people hurting me."

My fear is of being robbed, being hurt, people being in my house, people trying to get me—anything associated with any sort of physical harm.

My Life, Page ___.

Lisa: "When the robbery first happened, I didn't want to talk about it because I was always crying, and crying is embarrassing to me... No talking about it = no crying in public. I felt tremendous guilt because... heirloom jewelry was gone and I knew my parents would be upset... because I let my adult daughter enter the house before me, instead of me going in first to protect her if needed... because one of the cats got sick, probably due to the stress of strangers in her house... because one of my friends was diagnosed with breast cancer, and what was the big deal about having my house robbed?

All the guilt combined with the fear. I was fearful that people in the neighborhood were watching the house... I was angry because there had been strangers in my home, but I was also afraid of them. I had an alarm system installed.

I have lived in a mostly rainbow-y, glass-all-full existence for over 50 years, and this threw me off course, but it has also made me appreciate really important things like friends and family, MY space, MY home— not the building, but the spirit of how I felt (and am starting to feel again) when I was in it."

"I felt tremendous guilt because I didn't have extra insurance for my jewelry, and because I didn't put a dowel in the sliding glass door track, and because I don't lock my back gate."

"I was afraid of finding other things that were missing." "I was afraid to buy anything other than food because someone might steal it." — my comings and goings.

"I'm still afraid, but have healed a bit. I don't cry (often)..."

"I can talk about the robbery now, if I absolutely have to :-)"

3/9/12

(hand labels: poach, rustle, burglarize, snatch, swipe, filch, grab, remove, take, shaft, violate, heist, steal, loot, heist, rob)

ROBBERY
Lisa

When the robbery first happened, I didn't want to talk about it because I was always crying...

WRONGFUL IMPRISONMENT
Nic, 29

The idea of being wrongfully imprisoned by the state is a personal nightmare of mine.

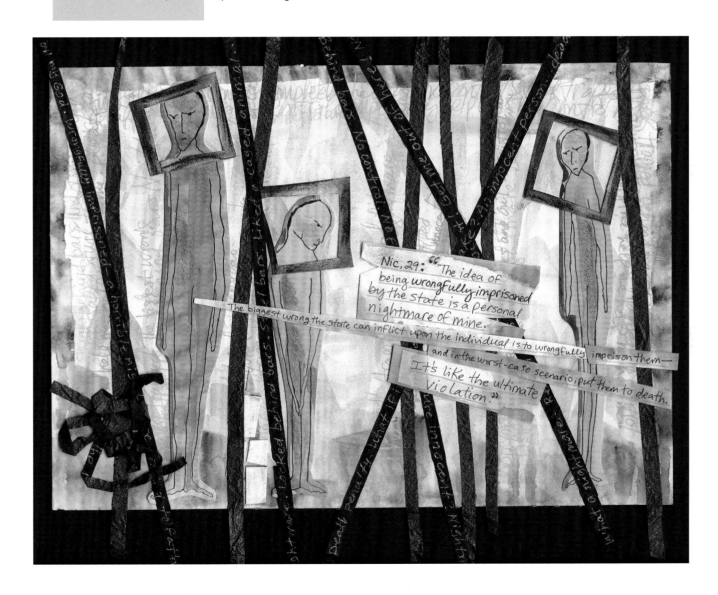

Nic, 29: "The idea of being wrongfully imprisoned by the state is a personal nightmare of mine. The biggest wrong the state can inflict upon the individual is to wrongfully imprison them — and in the worst-case scenario, put them to death. It's like the ultimate violation."

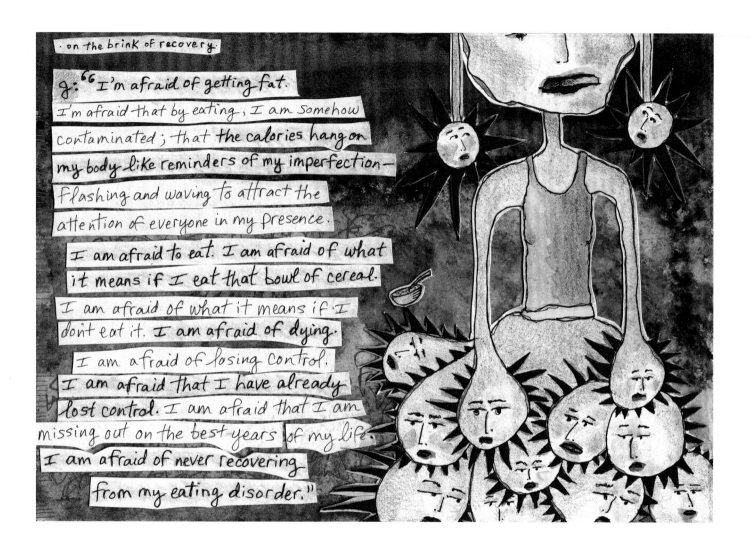

· on the brink of recovery ·

J: "I'm afraid of getting fat. I'm afraid that by eating, I am somehow contaminated; that the calories hang on my body like reminders of my imperfection— flashing and waving to attract the attention of everyone in my presence.

I am afraid to eat. I am afraid of what it means if I eat that bowl of cereal. I am afraid of what it means if I don't eat it. I am afraid of dying.

I am afraid of losing control. I am afraid that I have already lost control. I am afraid that I am missing out on the best years of my life. I am afraid of never recovering from my eating disorder."

GETTING FAT
J

I am afraid to eat. I am afraid of what it means if I eat that bowl of cereal. I am afraid of what it means if I don't eat it. I am afraid of dying. I am afraid of losing control. I am afraid that I have already lost control. I am afraid that I am missing out on the best years of my life.

I always knew I was an emotional eater, but I didn't know [that] I ate when I was scared.

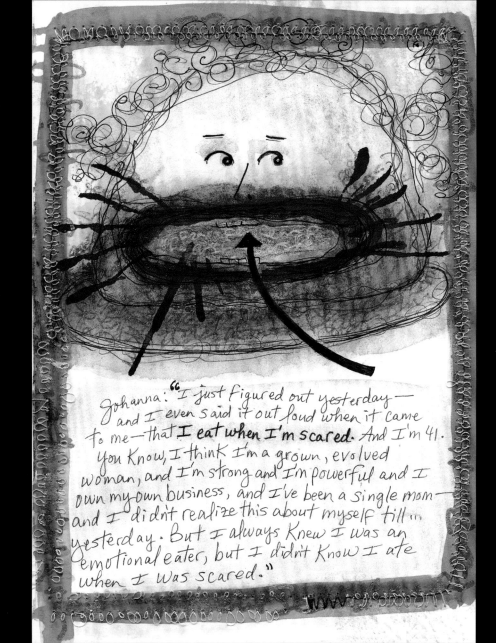

Johanna: "I just figured out yesterday—and I even said it out loud when it came to me—that I eat when I'm scared. And I'm 41. You know, I think I'm a grown, evolved woman, and I'm strong and I'm powerful and I own my own business, and I've been a single mom—and I didn't realize this about myself till yesterday. But I always knew I was an emotional eater, but I didn't know I ate when I was scared."

MAKING DECISIONS
Michelle, 22

Decision making has always been hard for me, from a Twix or Snickers deal, to what I want to do for a living.... I fear making the wrong decision and missing out on something else that could be amazing.

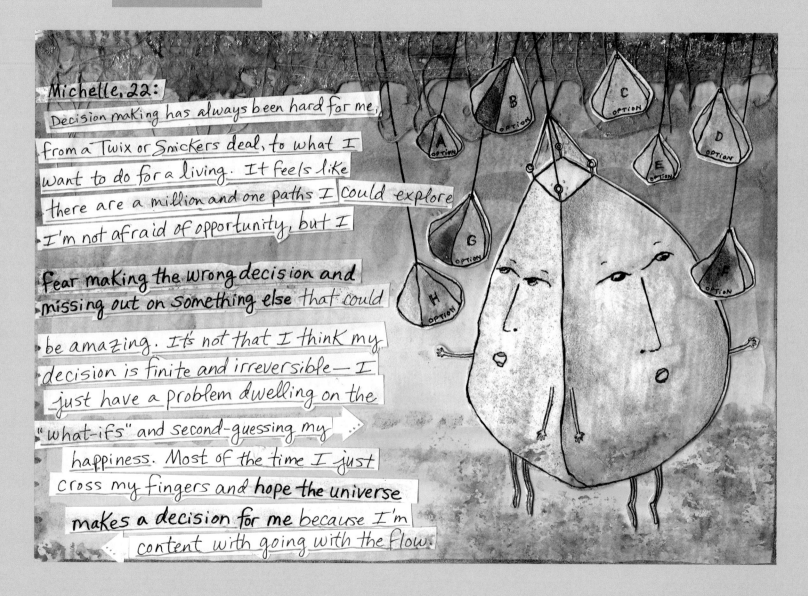

Michelle, 22:

Decision making has always been hard for me, from a Twix or Snickers deal, to what I want to do for a living. It feels like there are a million and one paths I could explore. I'm not afraid of opportunity, but I

fear making the wrong decision and missing out on something else that could

be amazing. It's not that I think my decision is finite and irreversible— I just have a problem dwelling on the "what-ifs" and second-guessing my happiness. Most of the time I just cross my fingers and hope the universe makes a decision for me because I'm content with going with the flow.

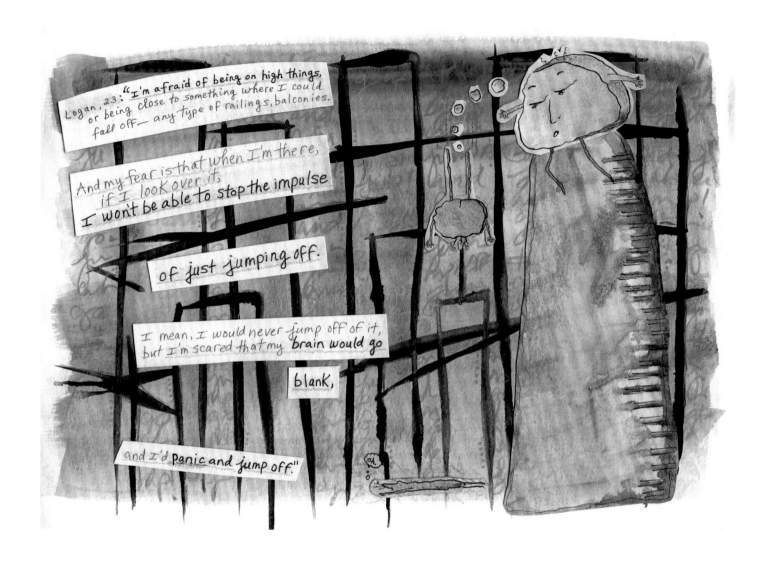

IMPULSE JUMP
Logan, 23

I'm afraid of being on high things, or being close to something where I could fall off—any type of railings, balconies…. I'm scared that my brain would go blank, and I'd panic and jump off.

PHONE ANXIETY
Mike, 29

Whenever the phone rings, I have a momentary paralysis...

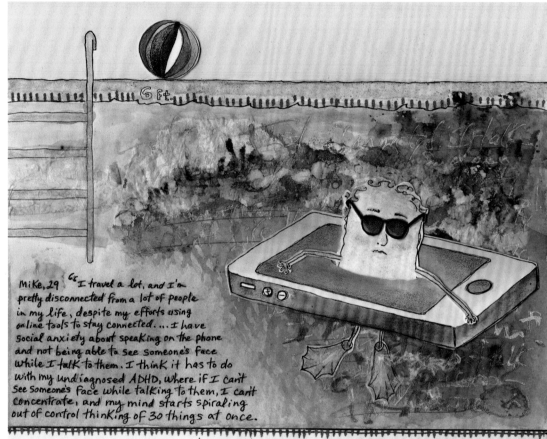

Mike, 29 "I travel a lot, and I'm pretty disconnected from a lot of people in my life, despite my efforts using online tools to stay connected. ...I have social anxiety about speaking on the phone and not being able to see someone's face while I talk to them. I think it has to do with my undiagnosed ADHD, where if I can't see someone's face while talking to them, I can't concentrate, and my mind starts spiraling out of control thinking of 30 things at once.

"But the added fear I have is not knowing that today, tomorrow, or even right now, someone is going to call me to tell me the news someone has died, about to die, or something has happened to my family.

Whenever the phone rings, I have a momentary paralysis where I can't muster the gumption to pick up the phone before a few rings. It's a power thing. For some reason I have no problem letting the phone call run out and then call them back almost right away — that way it's on my terms in some sense."

THE UNKNOWN
Sara, 22

Not knowing what tomorrow holds is quite scary.... So much is unknown.

Sara, 22: "Not Knowing what tomorrow holds is quite scary. No one Knows how their life will play out. We need to value and cherish what we have now, because at any time it could all be taken away from us. There is so much we think we Know, but really we have no idea.

So much is unKnown."

LONELINESS
TC

I always feel that I am in a dark space without anyone else....
I'm panicked and helpless.

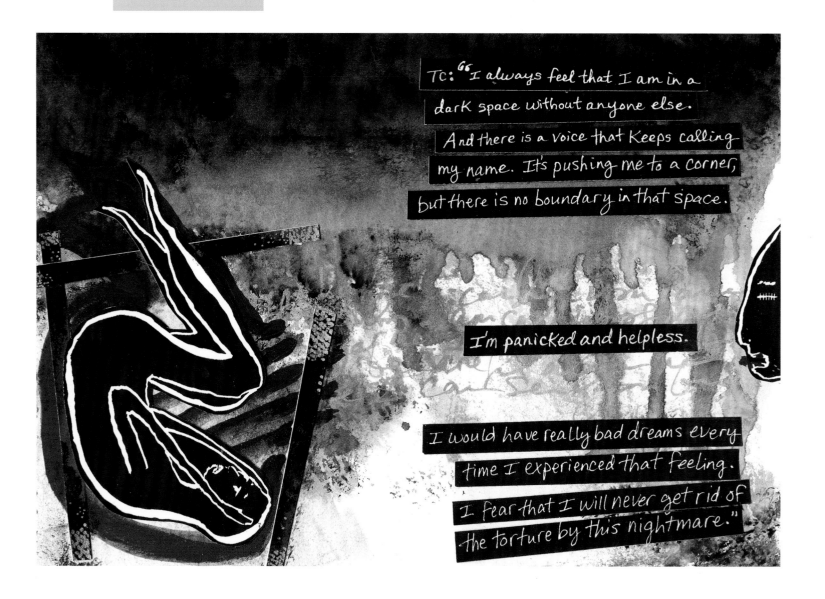

TC: "I always feel that I am in a dark space without anyone else.
And there is a voice that keeps calling my name. It's pushing me to a corner, but there is no boundary in that space.

I'm panicked and helpless.

I would have really bad dreams every time I experienced that feeling. I fear that I will never get rid of the torture by this nightmare."

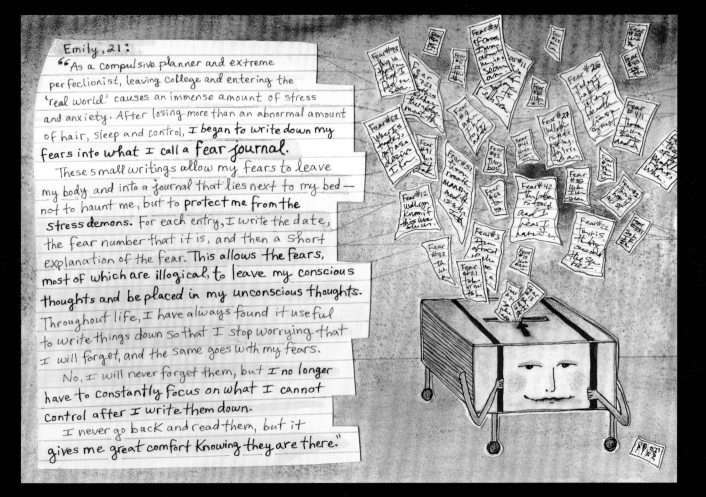

FEAR JOURNAL
Emily, 21

As a compulsive planner and extreme perfectionist, leaving college and entering the "real world" causes an immense amount of stress and anxiety.

Sasha, 38:

"I'm actually afraid to tell you my **BIGGEST, DEEPEST, DARKEST** fear.

I fear that voicing it will make it come true."

it's the biGGESt one...

it's the biGGEST one...

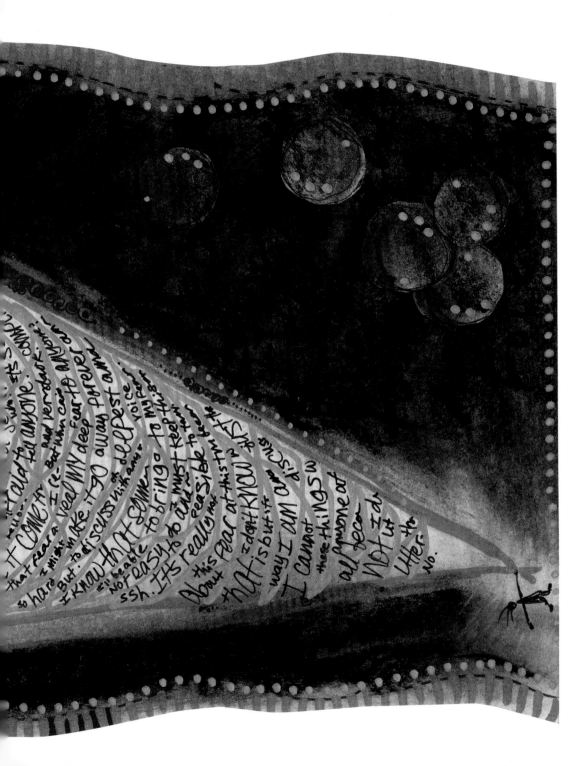

VOICING FEAR
Sasha, 38

I'm actually afraid to tell you my biggest, deepest, darkest fear. I fear that voicing it will make it come true.

I fear my cancer will come back, and I won't be able to beat it a second time.

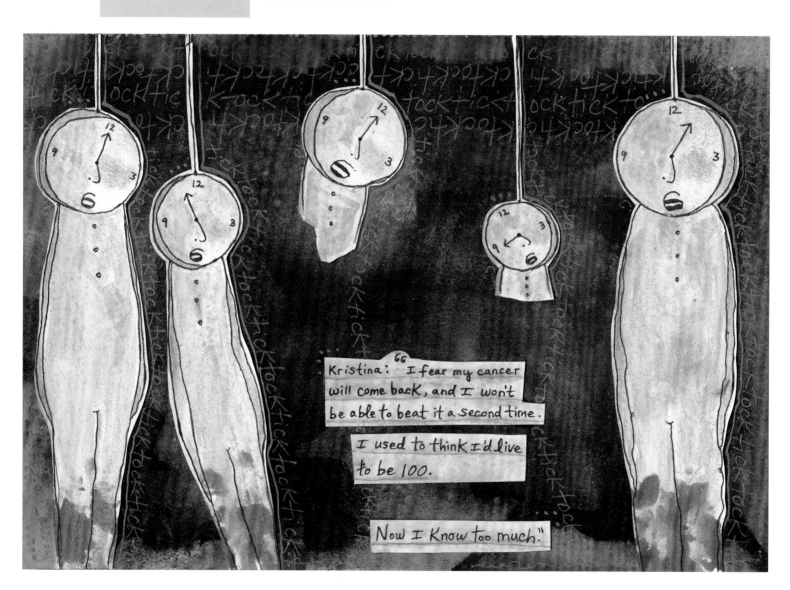

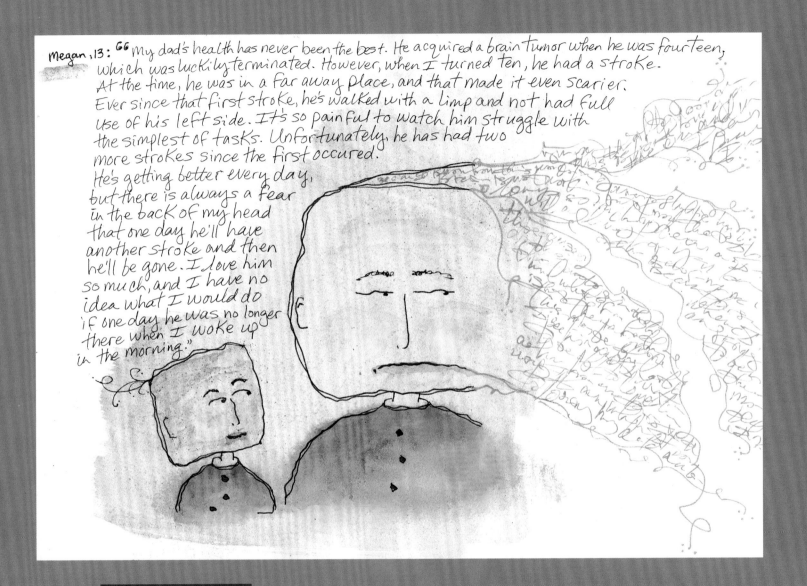

Megan, 13: "My dad's health has never been the best. He acquired a brain tumor when he was fourteen, which was luckily terminated. However, when I turned ten, he had a stroke. At the time, he was in a far away place, and that made it even scarier. Ever since that first stroke, he's walked with a limp and not had full use of his left side. It's so painful to watch him struggle with the simplest of tasks. Unfortunately, he has had two more strokes since the first occured.

He's getting better every day, but there is always a fear in the back of my head that one day he'll have another stroke and then he'll be gone. I love him so much, and I have no idea what I would do if one day he was no longer there when I woke up in the morning."

FATHER'S DEATH
Megan, 13

There is always a fear in the back of my head that one day [my father will] have another stroke and then he'll be gone.

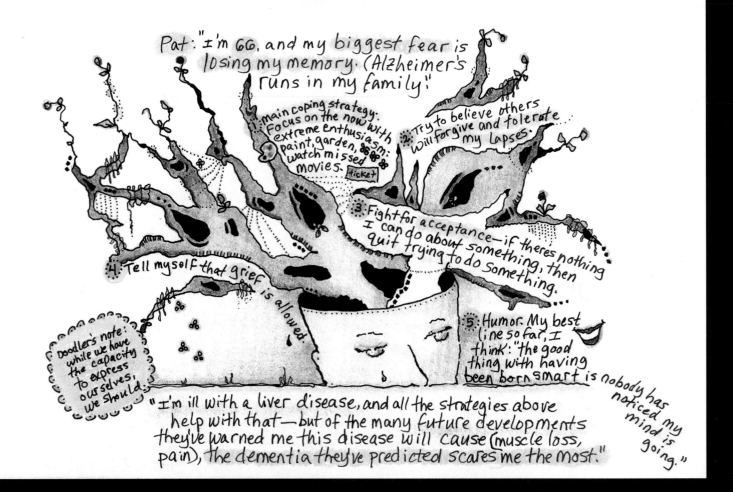

Pam, 53 I have a fear of getting Alzheimer's or dementia as I get older.

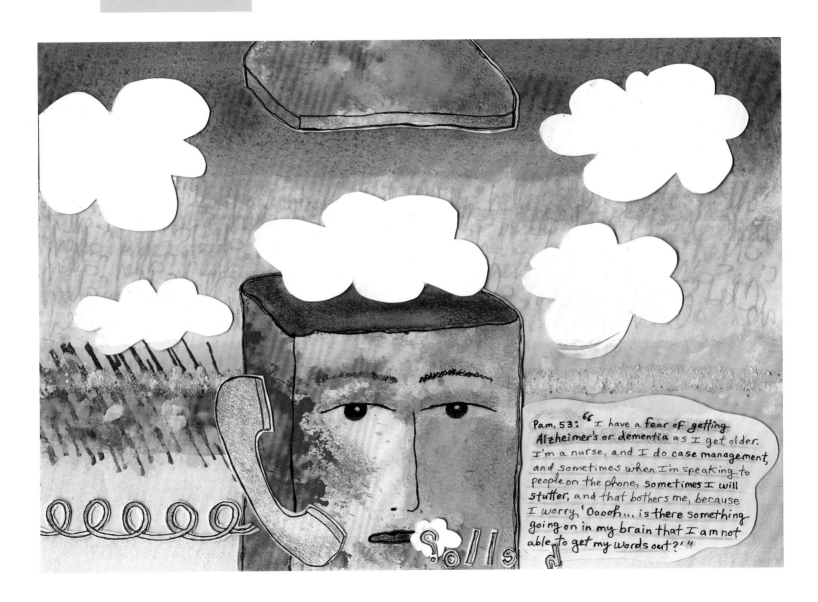

Pam, 53: "I have a fear of getting Alzheimer's or dementia as I get older. I'm a nurse, and I do case management, and sometimes when I'm speaking to people on the phone, sometimes I will stutter, and that bothers me, because I worry, 'Ooooh... is there something going on in my brain that I am not able to get my words out?'"

Jane, 85, was diagnosed with the early stages of dementia a year ago and has been living in an assisted-living facility for three months.

Judy, 63, daughter:
"My fears now are ending up like her. What do I do to prevent this happening to me? Right now I feel like I have 23 years left—and I'm hoping that I can learn to enjoy every day that I have now instead of letting the little things bother me. And you have to wipe the negative from your life. You just have to walk away from it..."

Jane: "I used to think it was scary getting old. It used to bother me. But it doesn't seem to bother me anymore."

When she first started getting forgetful:
"It just started, and then I knew what was going to happen. I was going to be like that—forgetful. And I am. I really am. It bothers me. I just can't remember."

About passing away:
"I know it's gonna happen. Sometimes I wish it'd hurry up." [small chuckle]

After she passes:
"I feel like ... that it's OK, whatever happens."

GENERATIONAL ALZHEIMER'S
Jane, 85, and Judy, 63

Jane was diagnosed with the early stages of dementia a year ago.

Jane:

I used to think it was scary getting old. It used to bother me. But it doesn't seem to bother me anymore.

Judy, her daughter:

My fears now are ending up like her. What do I do to prevent this happening to me?

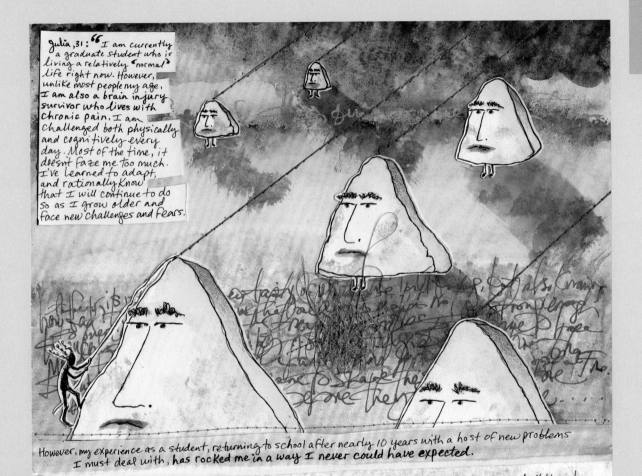

I am currently a graduate student who is living a relatively "normal" life right now. However, unlike most people my age, I am also a brain injury survivor who lives with chronic pain.... Life is supposed to be hard, but I fear too often that it isn't supposed to be this hard.

Julia, 31: " I am currently a graduate student who is living a relatively "normal" life right now. However, unlike most people my age, I am also a brain injury survivor who lives with chronic pain. I am challenged both physically and cognitively every day. Most of the time, it doesn't faze me too much. I've learned to adapt, and rationally know that I will continue to do so as I grow older and face new challenges and fears.

However, my experience as a student, returning to school after nearly 10 years with a host of new problems I must deal with, has rocked me in a way I never could have expected.

My return to school was integral to my own belief that I could face any challenge thrown my way if I could at least do this program. I've surpassed many people's expectations by enrolling here and accomplishing as much as I have thus far. But it has been at the expense of too much. My life feels too hard sometimes despite its relative simplicity. I'm not a victim of poverty, war or rape. I am just selfishly haunted by the fear of the little things.

The fear of returning back to the workforce and being exposed to the type of challenges that I've faced here and which I've barely overcome. Life is supposed to be hard, but I fear too often that it isn't supposed to be this hard. That I'm doing something wrong and

I don't know how to fix it. And I don't know how to prevent the potential of it becoming the status quo as I proceed into the next chapter of my life."

[My fear] is that I would be like my sister, who was mentally ill, who was an angry woman and very mean and hateful—and was abusive to everyone in her sphere.

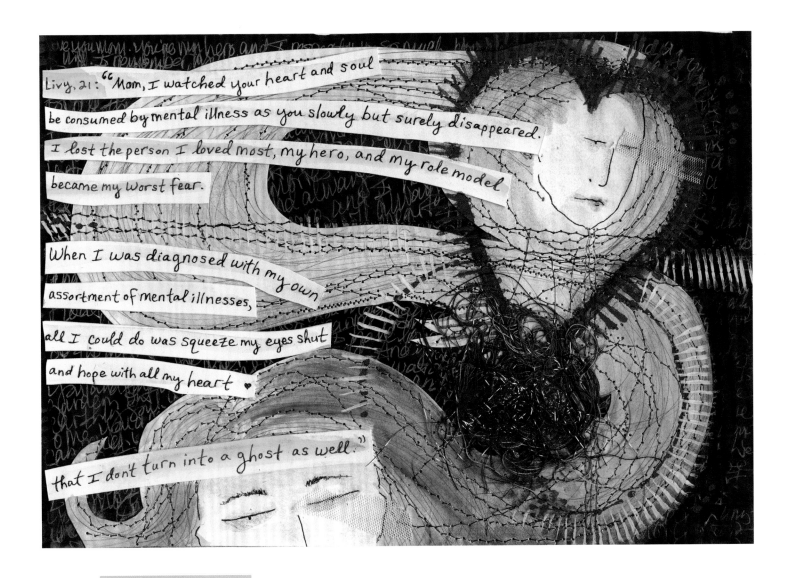

Livy, 21: "Mom, I watched your heart and soul be consumed by mental illness as you slowly but surely disappeared. I lost the person I loved most, my hero, and my role model became my worst fear.

When I was diagnosed with my own assortment of mental illnesses, all I could do was squeeze my eyes shut and hope with all my heart ♥ that I don't turn into a ghost as well."

MENTALLY ILL MOTHER
Livy, 21

Mom, I watched your heart and soul be consumed by mental illness as you slowly but surely disappeared.... When I was diagnosed with my own assortment of mental illnesses, all I could do was squeeze my eyes shut and hope with all my heart that I don't turn into a ghost as well.

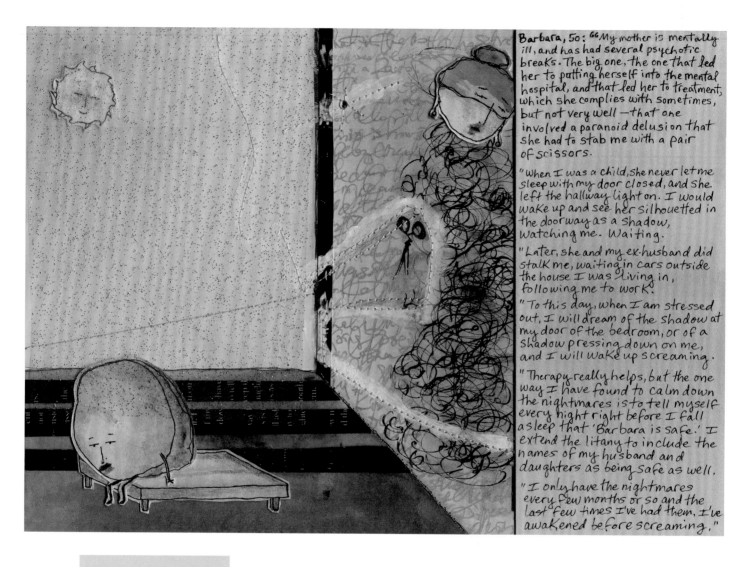

Barbara, 50: "My mother is mentally ill, and has had several psychotic breaks. The big one, the one that led her to putting herself into the mental hospital, and that led her to treatment, which she complies with sometimes, but not very well —that one involved a paranoid delusion that she had to stab me with a pair of scissors.

"When I was a child, she never let me sleep with my door closed, and she left the hallway light on. I would wake up and see her silhouetted in the doorway as a shadow, watching me. Waiting.

"Later, she and my ex-husband did stalk me, waiting in cars outside the house I was living in, following me to work.

"To this day, when I am stressed out, I will dream of the shadow at my door of the bedroom, or of a shadow pressing down on me, and I will wake up screaming.

"Therapy really helps, but the one way I have found to calm down the nightmares is to tell myself every night right before I fall asleep that 'Barbara is safe.' I extend the litany to include the names of my husband and daughters as being safe as well.

"I only have the nightmares every few months or so and the last few times I've had them, I've awakened before screaming."

STALKERS
Barbara, 50

My mother is mentally ill, and has had several psychotic breaks. The big one... involved a paranoid delusion that she had to stab me with a pair of scissors. When I was a child, she never let me sleep with my door closed, and she left the hallway light on. I would wake up and see her silhouetted in the doorway as a shadow, watching me. Waiting.

AFTER DEATH
Megan, 24

My fear is what happens after death. Not death itself, but what happens afterward. Is it forever? Are we going to be aware of ourselves after death? Or is it nothingness, forever?

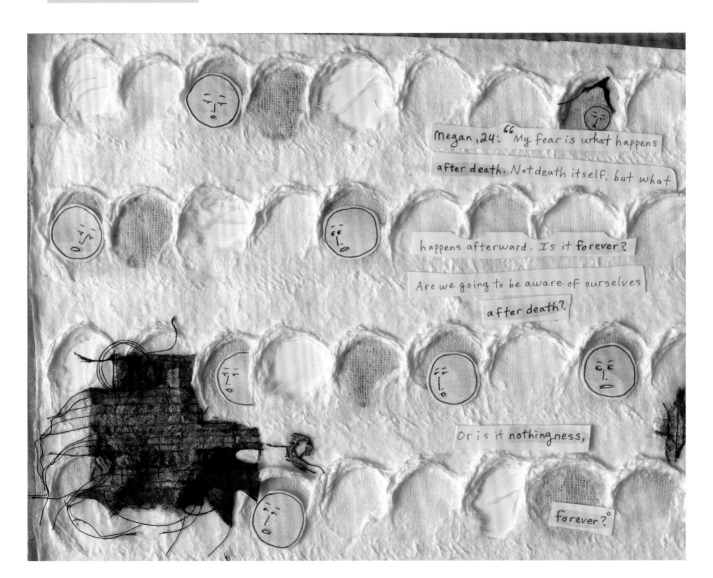

I was diagnosed in May with rheumatoid arthritis.... I'm a devout yogi, and I've never been in as good of shape as I am right now.... I fear that I don't have any idea how my joints will hold up for the rest of my life.

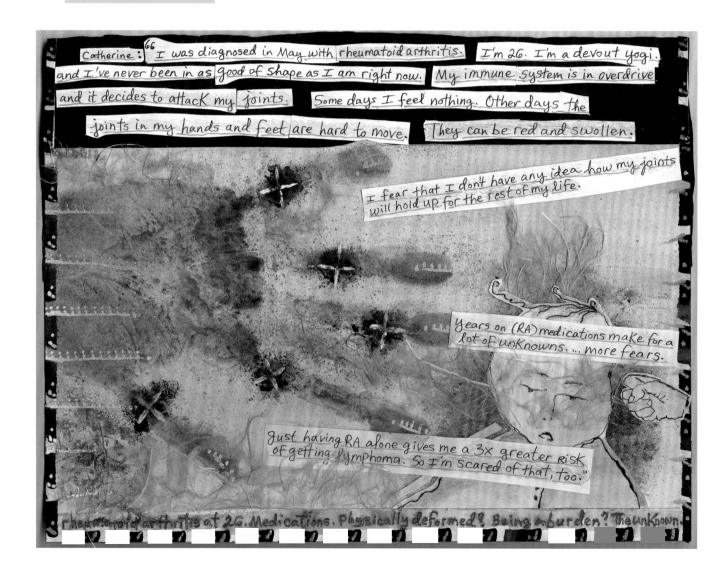

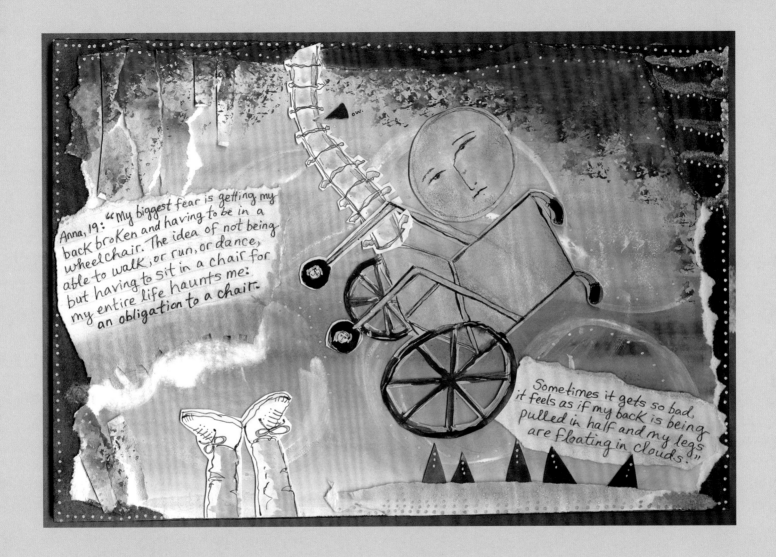

WHEELCHAIR
Anna, 19

My biggest fear is getting my back broken and having to be in a wheelchair. The idea of not being able to walk, or run, or dance, but having to sit in a chair for my entire life haunts me: an obligation to a chair.

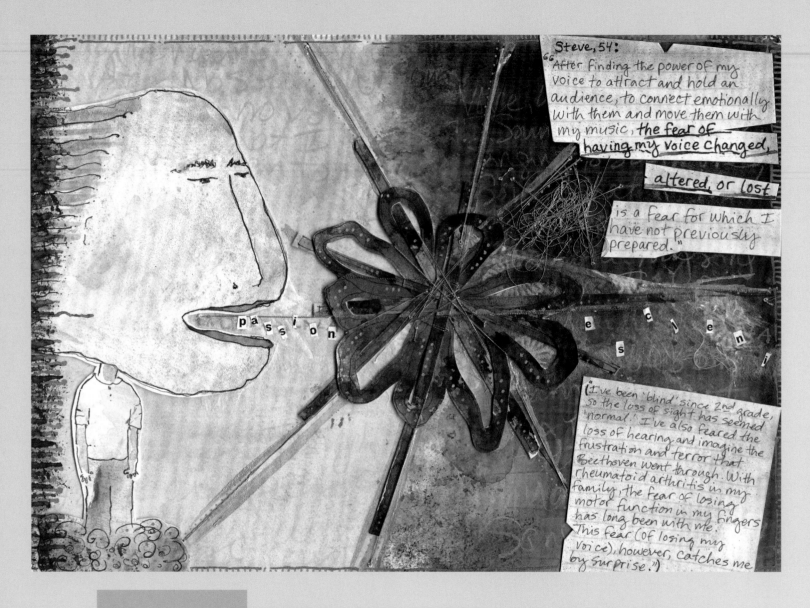

LOSING VOICE
Steve, 54

After finding the power of my voice to attract and hold an audience, to connect emotionally with them and move them with my music, the fear of having my voice changed, altered, or lost is a fear for which I have not previously prepared.

BLINDNESS

K, 55

My mother has been on the slow journey of losing her eyesight to macular degeneration.... My fear is that I will someday follow the lonely path toward darkness.

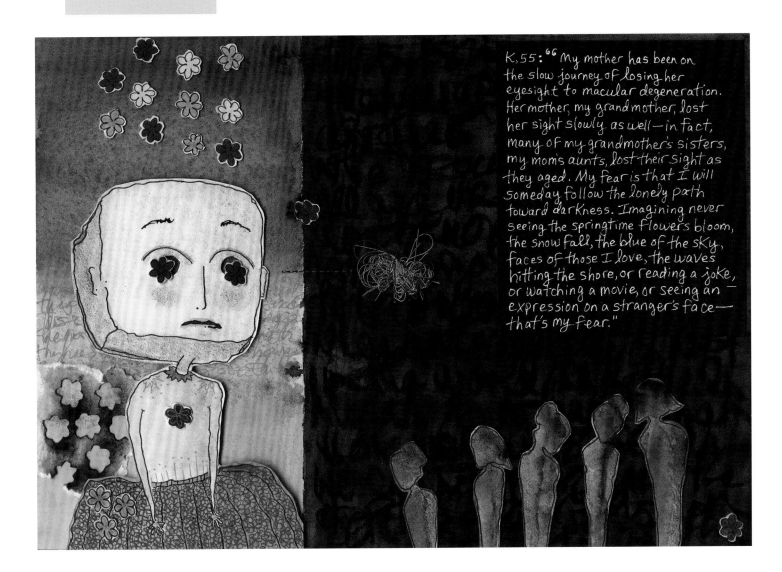

K,55: "My mother has been on the slow journey of losing her eyesight to macular degeneration. Her mother, my grandmother, lost her sight slowly as well—in fact, many of my grandmother's sisters, my mom's aunts, lost their sight as they aged. My fear is that I will someday follow the lonely path toward darkness. Imagining never seeing the springtime flowers bloom, the snow fall, the blue of the sky, faces of those I love, the waves hitting the shore, or reading a joke, or watching a movie, or seeing an expression on a stranger's face— that's my fear."

My real fear is developing breast cancer, but the specific fear that I have, which branches off from that, is losing my hair.

Josie, 22: "My real fear is developing breast cancer, but the specific fear that I have, which branches off from that, is losing my hair. When my mom had breast cancer, losing her hair was very traumatic for her. She said it came out in clumps in the shower, and every day it seemed like there was more and more until it was all gone. Now she can't stand it when there's hair trapped in the shower. — she gags and breaks out in goosebumps. Her hair was also (according to her) the only thing that made her look like me. Before chemo and radiation, her hair was curly just like mine. When it grew back in, it grew in stick-straight. I realized then how much our hair is tied to our identity. I've always been my mama's 'curly girl.' I can't imagine ever losing my curls. It would be like — no, it *would* be — losing part of who I am."

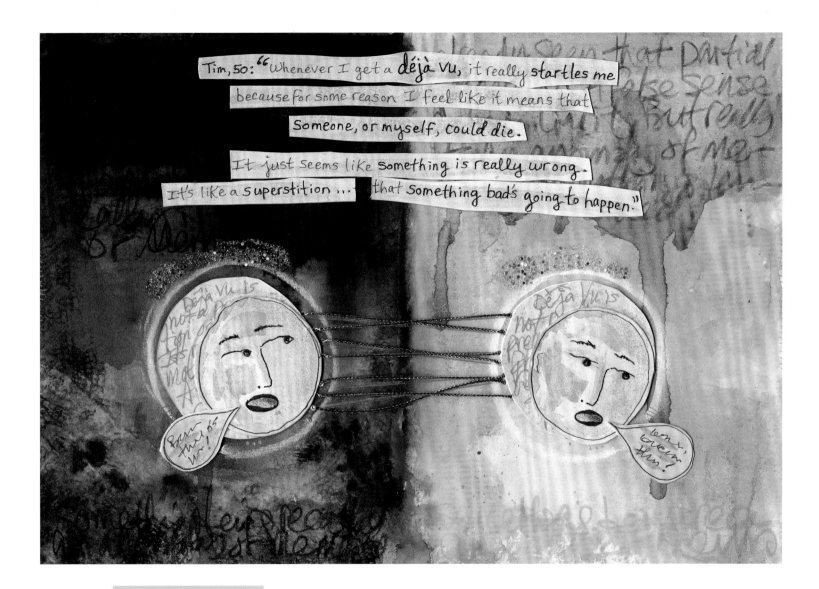

DÉJÀ VU
Tim, 50

Whenever I get a déjà vu, it really startles me because for some reason I feel like it means that someone, or myself, could die.

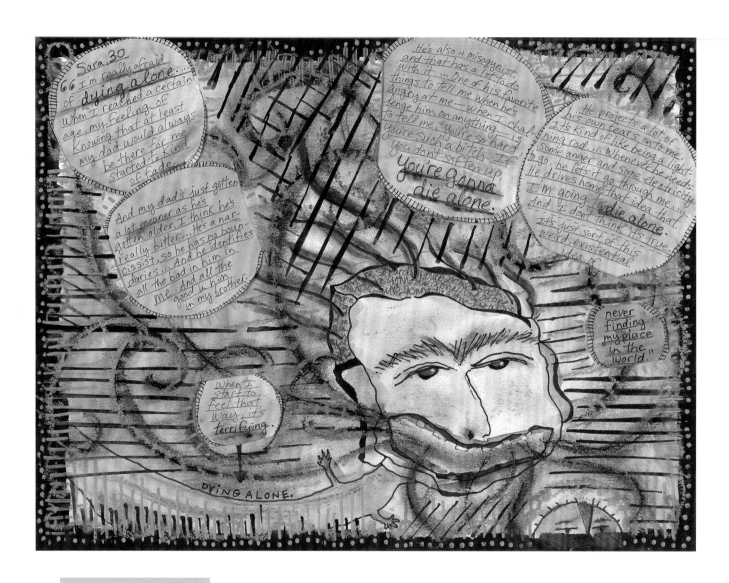

DYING ALONE

Sara, 30

I'm really afraid of dying alone....

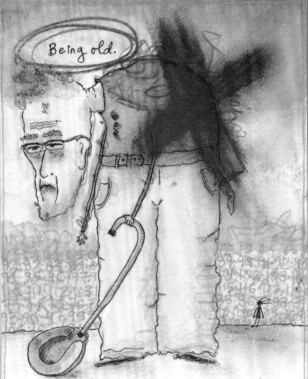

I am afraid of
becoming old and
being a burden on
my family.

NURSING HOME
Kate, 59

I have a fear of being in a nursing home or hospital and having a TV going all day and night in my room and I can't turn it off because it's not a private room and the norm there is to play the TV all the time.

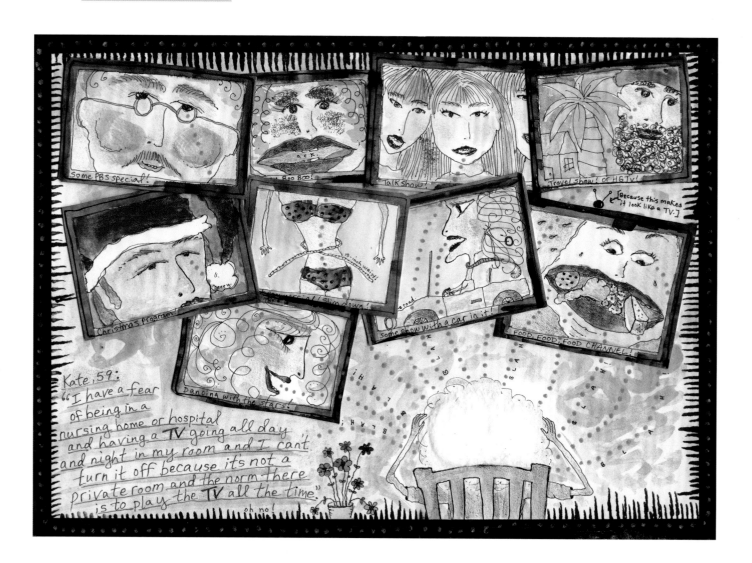

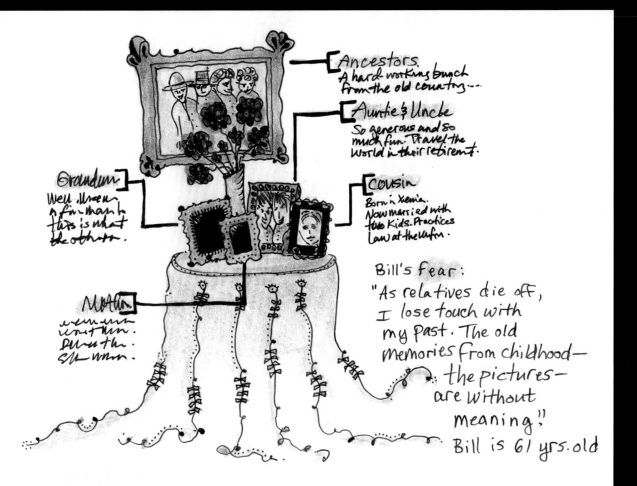

FADING MEMORIES
Bill, 61

As relatives die off, I lose touch with my past. The old memories from childhood—the pictures—are without meaning.

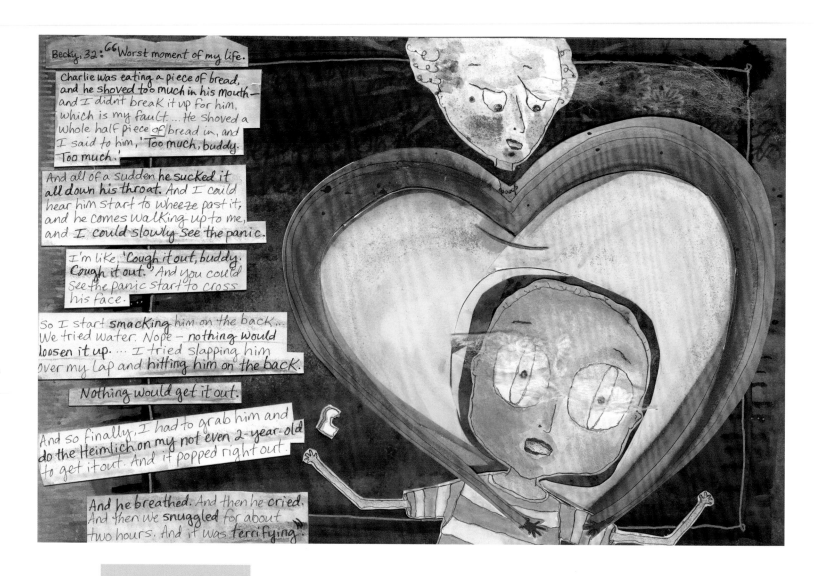

Becky, 32: "Worst moment of my life.

Charlie was eating a piece of bread, and he shoved too much in his mouth— and I didn't break it up for him, which is my fault. ... He shoved a whole half piece of bread in, and I said to him, 'Too much, buddy. Too much.'

And all of a sudden he sucked it all down his throat. And I could hear him start to wheeze past it, and he comes walking up to me, and I could slowly see the panic.

I'm like, 'Cough it out, buddy. Cough it out.' And you could see the panic start to cross his face.

So I start smacking him on the back... We tried water. Nope—nothing would loosen it up. ... I tried slapping him over my lap and hitting him on the back.

Nothing would get it out.

And so finally, I had to grab him and do the Heimlich on my not even 2-year-old to get it out. And it popped right out.

And he breathed. And then he cried. And then we snuggled for about two hours. And it was terrifying."

CHILD CHOKING
Becky, 32

Charlie was eating a piece of bread, and he shoved too much in his mouth....
And all of a sudden he sucked it all down his throat.

If I'm still asleep by 6:00 a.m., on any morning, the bad dreams kick in...most often they are about the death of children—and not always mine.

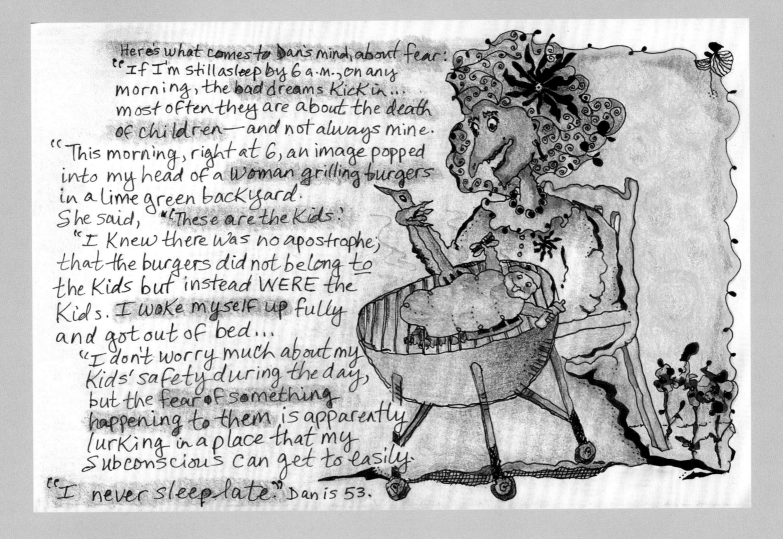

Here's what comes to Dan's mind, about fear:
"If I'm still asleep by 6 a.m., on any morning, the bad dreams kick in... most often they are about the death of children—and not always mine.

"This morning, right at 6, an image popped into my head of a woman grilling burgers in a lime green backyard.
She said, "These are the Kids."

"I knew there was no apostrophe; that the burgers did not belong to the Kids but instead WERE the Kids. I woke myself up fully and got out of bed...

"I don't worry much about my Kids' safety during the day, but the fear of something happening to them is apparently lurking in a place that my subconscious can get to easily.

"I never sleep late." Dan is 53.

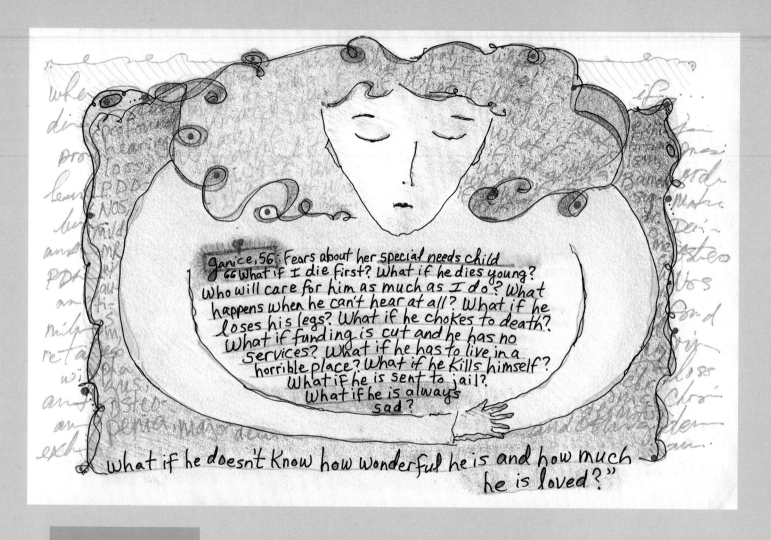

CHILD'S FUTURE
Janice, 56

Sharing fears about her special needs child:

What if I die first? What if he dies young? Who will care for him as much as I do? What happens when he can't hear at all? What if he loses his legs? What if he chokes to death? What if funding is cut and he has no services? What if he has to live in a horrible place? What if he kills himself? What if he is sent to jail? What if he is always sad? What if he doesn't know how wonderful he is and how much he is loved?

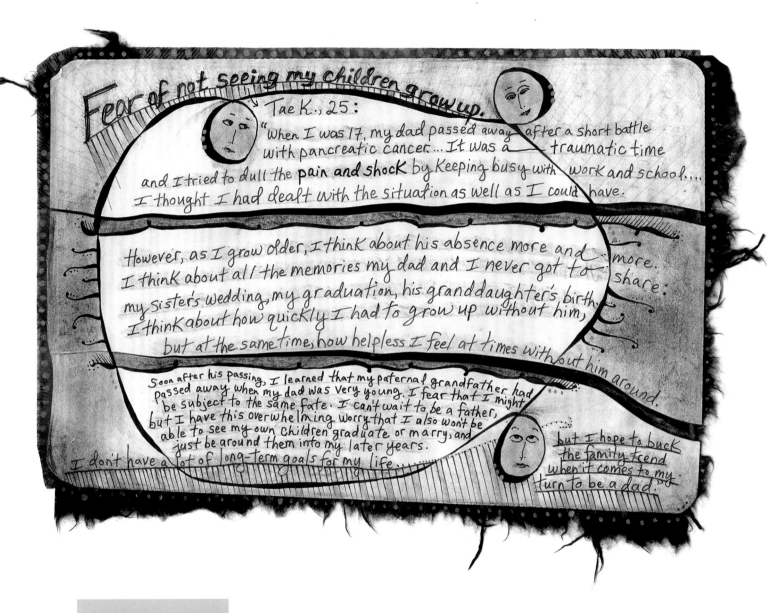

Fear of not seeing my children grow up.

Tae K., 25:

"When I was 17, my dad passed away after a short battle with pancreatic cancer.... It was a ___ traumatic time and I tried to dull the **pain and shock** by keeping busy with work and school.... I thought I had dealt with the situation as well as I could have.

However, as I grow older, I think about his absence more and more. I think about all the memories my dad and I never got to share: my sister's wedding, my graduation, his granddaughter's birth. I think about how quickly I had to grow up without him, but at the same time, how helpless I feel at times without him around.

Soon after his passing, I learned that my paternal grandfather had passed away when my dad was very young. I fear that I might be subject to the same fate. I can't wait to be a father, but I have this overwhelming worry that I also won't be able to see my own children graduate or marry, and just be around them into my later years. I don't have a lot of long-term goals for my life.... but I hope to buck the family trend when it comes to my turn to be a dad."

DYING YOUNG
Tae K, 25

When I was 17, my dad passed away after a short battle with pancreatic cancer.... I fear that I might be subject to the same fate.

MOTHER'S SUICIDE
K, 20

Since childhood, I've been afraid of walking into my parent's house one day to find that my mother has killed herself.

126

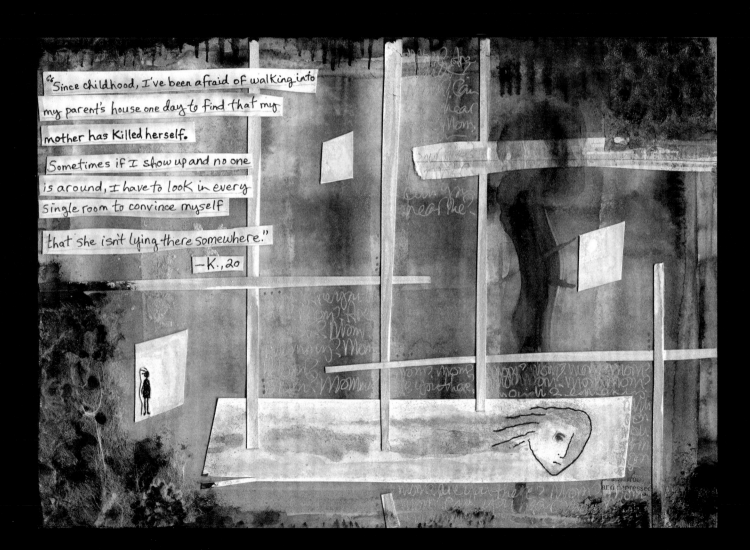

"Since childhood, I've been afraid of walking into my parent's house one day to find that my mother has killed herself.

Sometimes if I show up and no one is around, I have to look in every single room to convince myself

that she isn't lying there somewhere."

—K., 20

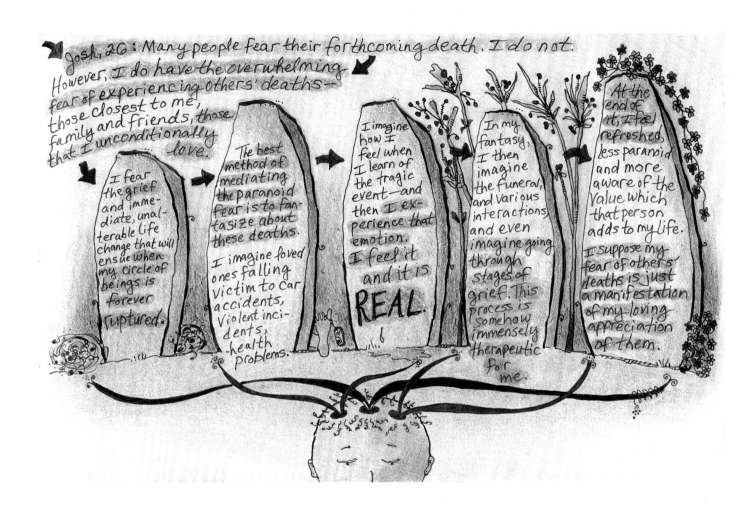

Josh, 26: Many people fear their forthcoming death. I do not. However, I do have the overwhelming fear of experiencing others' deaths— those closest to me, family and friends, those that I unconditionally love.

I fear the grief and immediate, unalterable life change that will ensue when my circle of beings is forever ruptured.

The best method of mediating the paranoid fear is to fantasize about these deaths.

I imagine loved ones falling victim to car accidents, violent incidents, health problems.

I imagine how I feel when I learn of the tragic event—and then I experience that emotion. I feel it and it is **REAL**.

In my fantasy, I then imagine the funeral, and various interactions, and even imagine going through stages of grief. This process is somehow immensely therapeutic for me.

At the end of it, I feel refreshed, less paranoid and more aware of the value which that person adds to my life.

I suppose my fear of others' deaths is just a manifestation of my loving appreciation of them.

OTHERS' DEATHS
Josh, 26

Many people fear their forthcoming death. I do not. However, I do have the overwhelming fear of experiencing others' deaths...

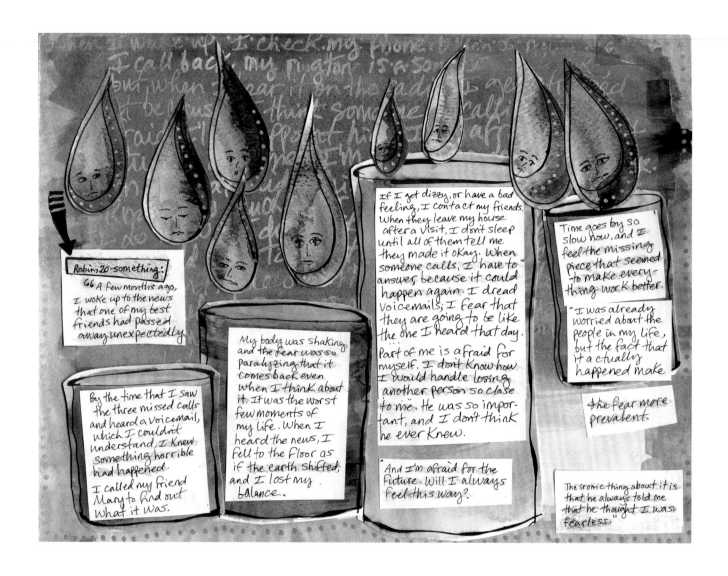

FRIEND'S DEATH
Robin, 20-something

A few months ago, I woke up to the news that one of my best friends had passed away unexpectedly.... I'm afraid for the future. Will I always feel this way?

DROWNING
Kelee, 43

My fear is drowning in very cold water—at night, when it's really dark, and it's very cold. That would be a really sad and lonely death.

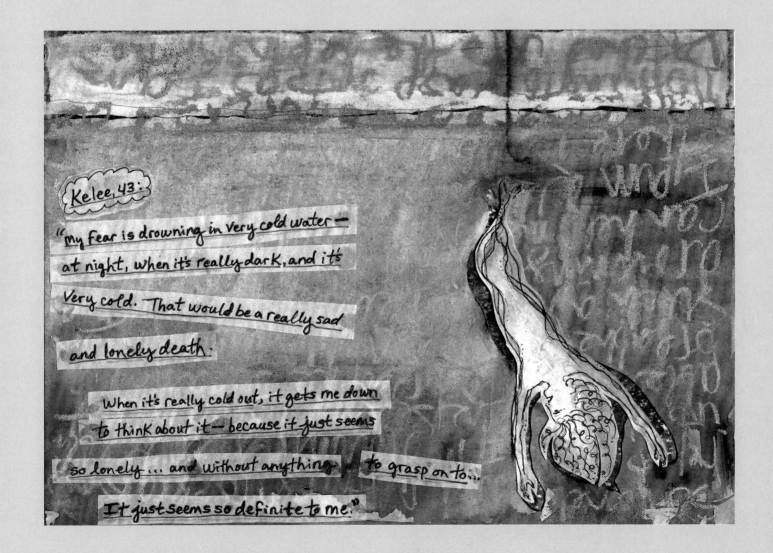

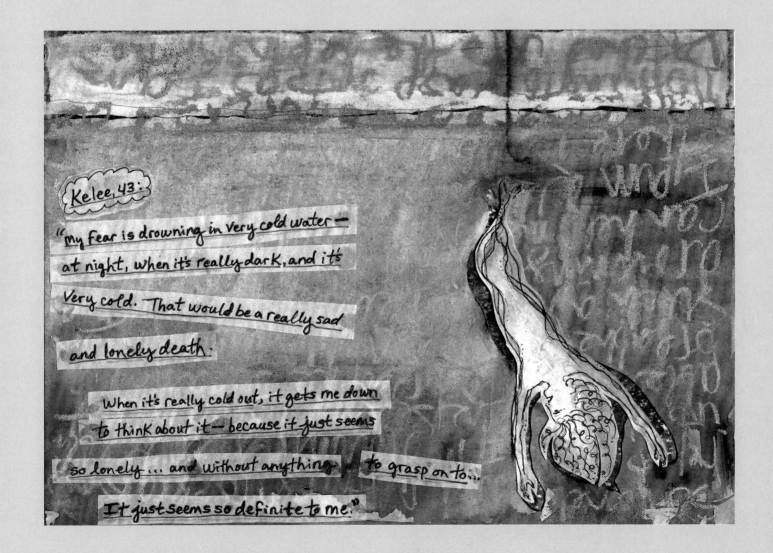Kelee, 43:

"my fear is drowning in very cold water — at night, when it's really dark, and it's very cold. That would be a really sad and lonely death.

When it's really cold out, it gets me down to think about it — because it just seems so lonely ... and without anything to grasp on to... It just seems so definite to me."

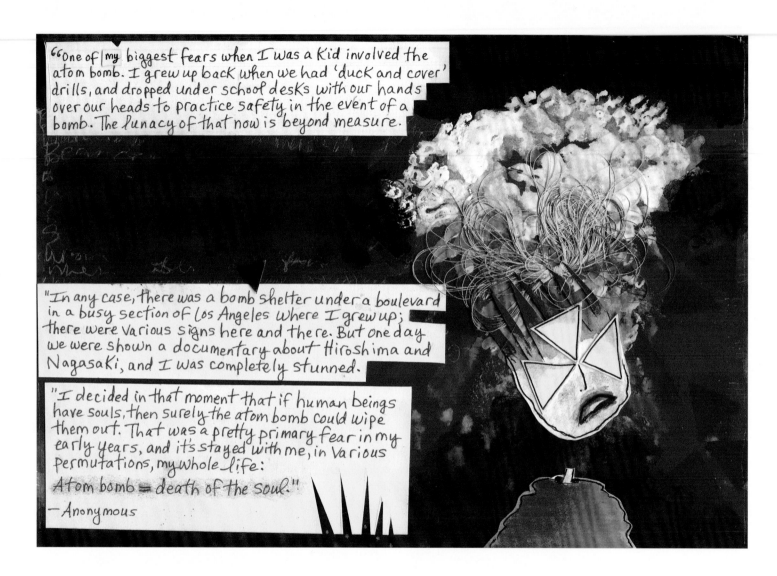

"One of my biggest fears when I was a kid involved the atom bomb. I grew up back when we had 'duck and cover' drills, and dropped under school desks with our hands over our heads to practice safety in the event of a bomb. The lunacy of that now is beyond measure.

"In any case, there was a bomb shelter under a boulevard in a busy section of Los Angeles where I grew up; there were various signs here and there. But one day we were shown a documentary about Hiroshima and Nagasaki, and I was completely stunned.

"I decided in that moment that if human beings have souls, then surely the atom bomb could wipe them out. That was a pretty primary fear in my early years, and it's stayed with me, in various permutations, my whole life:

Atom bomb = death of the soul."

—Anonymous

APOCALYPSE
Anonymous

I decided...that if human beings have souls, then surely the atom bomb could wipe them out. That was a pretty primary fear in my early years, and it's stayed with me, in various permutations, my whole life: Atom bomb = death of the soul.

From a *New York Times* story by Jonathan Martin and Dalia Sussman (12/10/15):

TERRORIST
ATTACK

Americans are more fearful about the likelihood of another terrorist attack than at any other time since the weeks after September 11, 2001, a gnawing sense of dread that has helped lift Donald J. Trump to a new high among Republican-primary voters, according to the latest *New York Times*/CBS News poll.

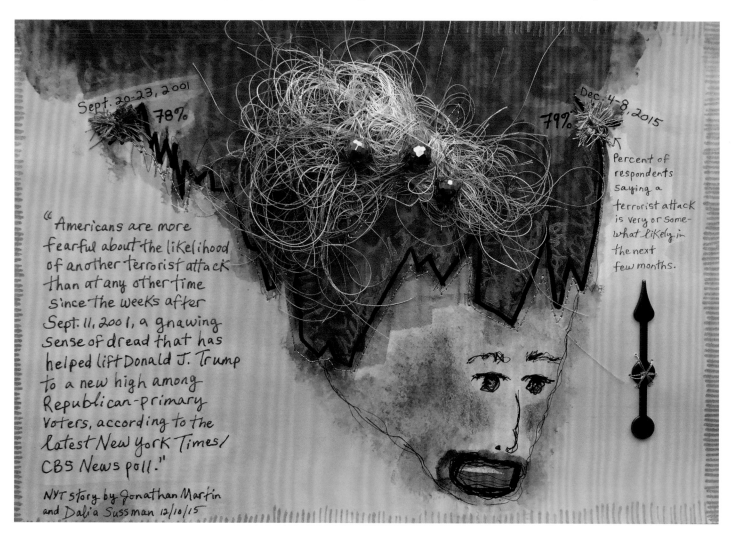

Sept. 20-23, 2001
78%

Dec. 4-8, 2015
79%

Percent of respondents saying a terrorist attack is very or some-what likely in the next few months.

" Americans are more fearful about the likelihood of another terrorist attack than at any other time since the weeks after Sept. 11, 2001, a gnawing sense of dread that has helped lift Donald J. Trump to a new high among Republican-primary voters, according to the latest New York Times/ CBS News poll."

NYT story by Jonathan Martin and Dalia Sussman 12/10/15

More than 5,000 readers responded to this question posed by
The New York Times after the mass shooting in San Bernardino,
California: How often, if ever, do you think about the possibility
of a shooting in your daily life? Linda, 68: "I think about
it every time I think of my grandchildren at school,
fearing their schools will be shot up. I despise having to
plan an exit strategy for myself every time I go
anywhere, but I do. I want to be ready to run when I
hear the first shot. Some might call me 'hypersensitized,'
but I call myself prepared and realistic. No one
is safe in America."

DAILY-LIFE SHOOTINGS
Linda, 68

Responding to a *New York Times* question about mass shootings:

I despise having to plan an exit strategy for myself every time I go anywhere, but I do. I want to be ready to run when I hear the first shot. Some might call me "hypersensitized," but I call myself prepared and realistic. No one is safe in America.

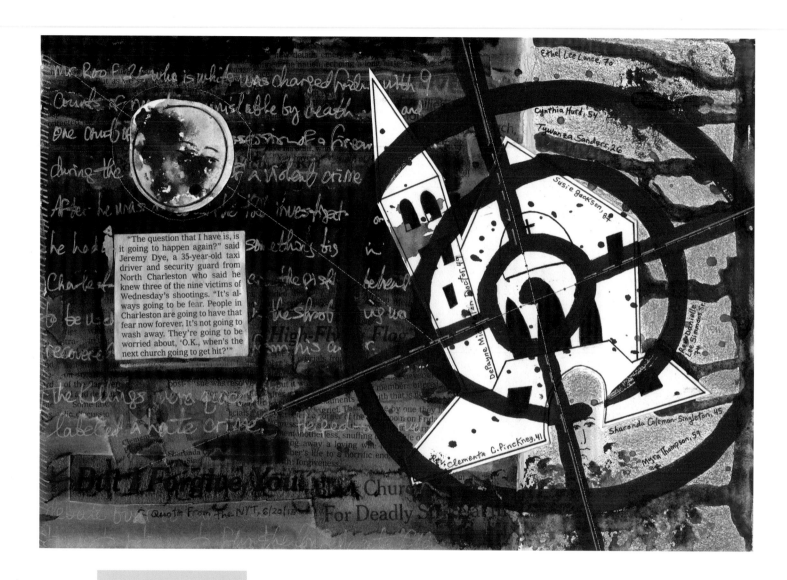

"The question that I have is, is it going to happen again?" said Jeremy Dye, a 35-year-old taxi driver and security guard from North Charleston who said he knew three of the nine victims of Wednesday's shootings. "It's always going to be fear. People in Charleston are going to have that fear now forever. It's not going to wash away. They're going to be worried about, 'O.K., when's the next church going to get hit?'"

Ethel Lee Lance, 70

Cynthia Hurd, 54

Tywanza Sanders, 26

Susie Jackson, 87

DePayne Middleton-Doctor, 49

Ree Rochialle Lee Simmons Sr. 74

Rev. Clementa C. Pinckney, 41

Sharonda Coleman-Singleton, 45

Myra Thompson, 59

Quote from The NYT, 6/20/15

CHURCH MASSACRE

"Fear stalks a city."

AMERICA'S NEW NORM

Anonymous

I fear the new norm
in America is to live in
fear, anger, and violence.
I fear that we are the
frog in cold water that's
being heated slowly, so
it's harder to perceive
any danger. The water
eventually boils, and the
frog is cooked to death.

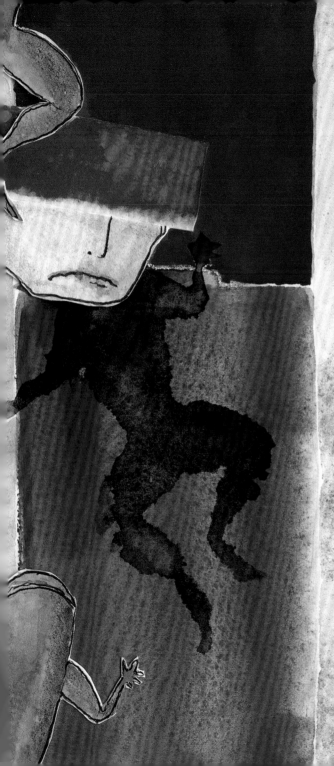

66 I fear the new norm in America is to live in fear, anger and violence. I fear that we are the frog in cold water that's being heated slowly, so it's harder to perceive any danger. The water eventually boils, and the frog is cooked to death.

"Violence, terrorism, fear give way to more surveillance and less trust. I fear that we're being trained to view everyone around us as suspects. We see and hear about terrorism so much that it becomes a the way of life.

"I fear that we won't be able to have open dialogues about controversial issues such as vaccines, gmo foods and gun laws. If someone has a different opinion than you, then they're automatically a quack.

"There's no dialogue and meaning.

"I fear for the future of America in all aspects that make a nation and its people."

– Anonymous

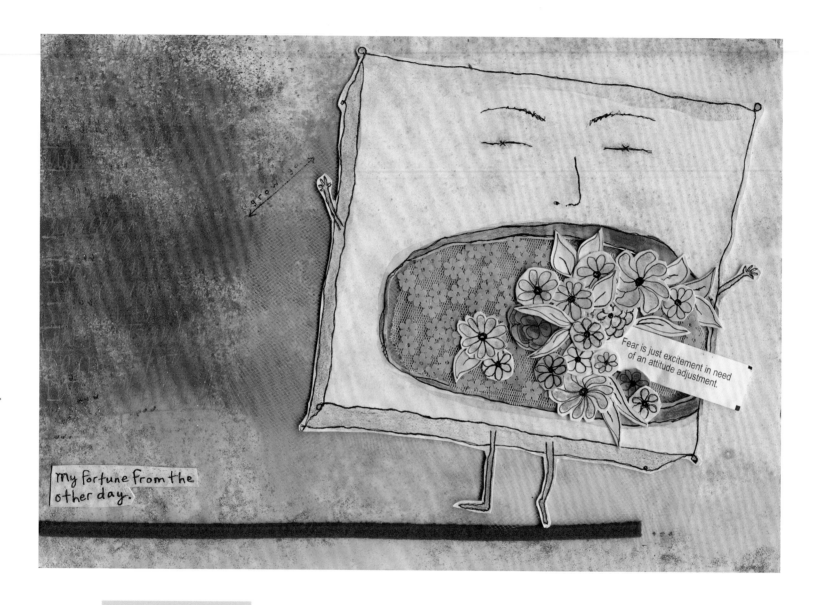

FORTUNE
Julie, 52

Fear is just excitement in need of an attitude adjustment.

Acknowledgments

First and foremost, I want to express my tremendous gratitude toward everyone who has shared his or her fear with me as I worked on this project. These people—some I know and many who I've never met—trusted me to treat their fear stories with integrity.

To those who cheered me on from the very beginning of this project, I thank you. Your ongoing encouragement, comments, and shout-outs helped me realize that this project was somehow making a difference out there.

I've been deeply moved by the responses I've received from so many people who have encountered the Fear Project. Their questions and the insights they've shared with me have helped me understand that while coping with fear itself can be scary, it can also be uplifting.

To Debra Ollivier at Parallax Press—thank you, thank you for reaching out to me, a complete stranger, after you stumbled across the Fear Project somewhere online. I am so grateful for your enthusiasm and support for moving this project forward. And to everyone else at Parallax, including Rachel Neumann, Terri Saul, Nancy Fish, and Terry Barber, thank you for standing behind *Fear, Illustrated*.

To John Barnett, thank you so much for finding a way to showcase the spirit of these illustrations through your design vision.

And, finally, a standing ovation goes to Jody Grenert for being there throughout this entire journey and encouraging me to be fearless, every step of the way.

Index

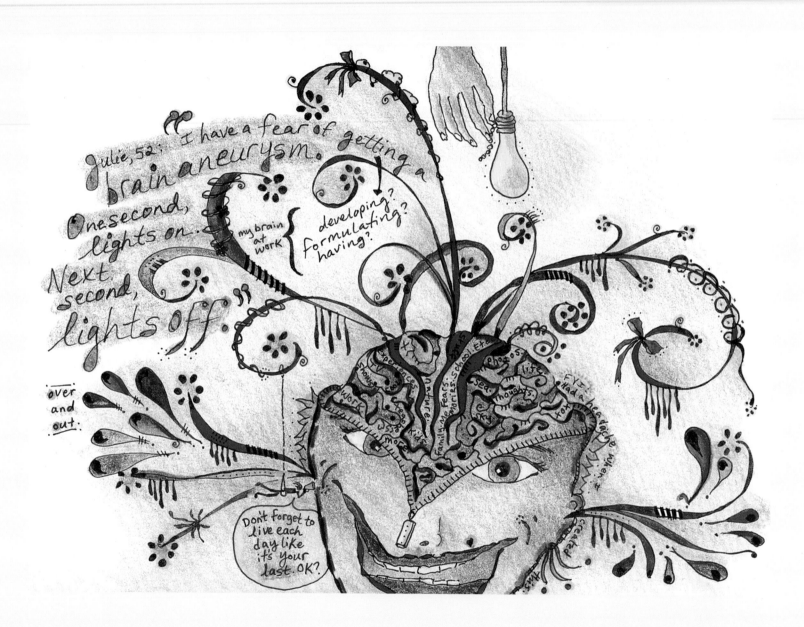

About the Author

J ulie M. Elman lives in Athens, Ohio, with her husband. She teaches design
in the School of Visual Communication at Ohio University in Athens, Ohio.

**BRAIN
EXPLOSION**
Julie, 52

I have a fear of getting a brain aneurysm. One second, lights on.
Next second, lights off.

PARALLAX PRESS

Parallax Press is a nonprofit publisher, founded and inspired by Zen Master Thich Nhat Hanh. We publish books on mindfulness in daily life and are committed to making these teachings accessible to everyone and preserving them for future generations. We do this work to alleviate suffering and contribute to a more just and joyful world.

For a copy of the catalog, please contact:

Parallax Press
P.O. Box 7355
Berkeley, CA 94707
parallax.org

RELATED TITLES FROM PARALLAX PRESS

Anh's Anger, Gail Silver
Calming the Fearful Mind: A Zen Response to Terrorism, Thich Nhat Hanh
Clouds in a Teacup, Thich Nhat Hanh and Brett Cook
Drawing Your Own Path, John F. Simon, Jr.
How to Live, Thich Nhat Hanh
Moments of Mindfulness, Thich Nhat Hanh and Jenifer Kent
Pass it On, Joanna Macy
Sacred Places, Thich Nhat Hanh and Jason DeAntonis
Small Bites, Annabelle Zinser
Ten Breaths to Happiness, Glen Schneider